IMAGES
of America

HOLY CITY
OF THE WICHITAS

On the cover: Please see page 115. (Jonna Lowry collection.)

IMAGES
of America

HOLY CITY
OF THE WICHITAS

Jacqulein Vaughn Lowry

ARCADIA
PUBLISHING

Copyright © 2009 by Jacqulein Vaughn Lowry
ISBN 978-0-7385-6004-5

Published by Arcadia Publishing
Charleston SC, Chicago IL, Portsmouth NH, San Francisco CA

Printed in the United States of America

Library of Congress Control Number: 2009924654

For all general information contact Arcadia Publishing at:
Telephone 843-853-2070
Fax 843-853-0044
E-mail sales@arcadiapublishing.com
For customer service and orders:
Toll-Free 1-888-313-2665

Visit us on the Internet at www.arcadiapublishing.com

*To everyone who left their footprints and heart at
the Holy City of the Wichitas*

CONTENTS

Acknowledgments		6
Introduction		7
1.	The Beginning	9
2.	The Holy City	17
3.	The Chapel	37
4.	The Film	49
5.	The Statue	59
6.	The Grounds	65
7.	The Pageant	99

Acknowledgments

I feel honored to have been asked to put on paper the rich history of the Holy City of the Wichitas. For every picture, there have been 1,000 stories for which there is no photograph. I have a deep appreciation for all volunteers who have gone before and whose dedication and devotion as cast members kept the *Prince of Peace* pageant alive. A heartfelt thank-you to so many who helped along the way: my daughter Jonna, without whose nimble fingers on her laptop computer, this would not have been possible; my husband, Jon, who overlooked tables piled with history; my entire family, whose excitement gave me extra energy; the cast of thousands who left boxes of notes, pictures, and news articles for me to search; the *Daily Oklahoman* and the *Lawton Constitution* for publishing those beautifully written accounts of the Holy City history; and the historical society newspaper room that preserved them on miles of microfilm. A thank-you to ConocoPhillips Archives, Indiana University, and Unity Institute; to Debbie Rose for her computer knowledge she so willingly shared; to Ted Gerstle, my editor at Arcadia Publishing, who was always ready with encouraging words; to Annette Briley, who was always available; and to John R. Lovett, assistant curator, University of Oklahoma, for supplying pictures of the early history of the Holy City to replace those that had been destroyed in the original Wallock Memorial Museum. A special thank-you to Flo Parker, who held not only this project in her prayers but me as well. Thank you, thank you to each one who had a part in making this project complete.

Introduction

*How beautiful upon the mountains are the feet of him
that bringeth good tidings, that publisheth peace.*

—Isaiah 52:7

As for any person with a love of history, there is the desire for as many facts as possible to be preserved. People arrive at many historical sites only to find a modern structure or a small plaque marking the spot. This makes a picture history even more important for future generations.

The Holy City of the Wichitas is as it has always been. The buildings and grounds are exactly as they were in 1936 when the location inside the Wichita Mountains Wildlife Refuge was opened. The original site had been on a privately owned mountain in Medicine Park, four miles to the east of the present Holy City grounds. Rev. Anthony Mark Wallock, founder of the *Prince of Peace* pageant, was pastor of the First Congregational Church in Lawton. He had also organized a Sunday school class in Medicine Park. Wallock, along with the class members, climbed the mountain at dawn on Easter morning in 1926 and held a short service as class members pantomimed the Resurrection scene. They sang three songs while a violin was played. Through the years as news about this unique Easter service spread, the crowds grew so large that within nine years visitors had to be turned away. Wallock selected the site where the Holy City remains today after the original location was outgrown.

Pres. Franklin Delano Roosevelt granted a use permit for the area. He had labeled a folder in Washington, D.C., "The Holy City," which contained Easter service information coming from Oklahoma. The permanent buildings on the new site were constructed by 150 craftsmen who were hired by the Works Progress Administration (WPA) to first build the structures of wood. Later the ancient-looking buildings and facades were faced with concrete and native stone and made to resemble the Holy Land. They remain today exactly as they built them.

The crowds grew rapidly in number until more than 100,000 people were present to witness what had become known as the *Prince of Peace* pageant. In 1936, Roosevelt sent a telegram that was read at the pageant's opening. It said, "To all of sincere faith, the dawn of this Easter day in the Wichita Mountains will bring the same message of hope that the angel of the Resurrection brought to the holy women at the tomb of the Master in the hills of Judea." Representatives in Washington, D.C., were so impressed with the news coming from the Holy City of the Wichitas that in 1937 a government representative, Andy Connelly, was sent to make a full-length film to update them.

The Holy City Chapel has always been the jewel in the Holy City setting and is the one building most associated with the Holy City. It has figured prominently on many souvenir items sold in the Lawton area during the 1930s. The Holy City Chapel was built with walls four feet thick and resembles the Sistine Chapel. The beautiful artwork, complete with life-size angels painted on the ceiling and portraits of the 12 disciples displayed on the walls, took Lawton native artist Irene Malcolm seven years to complete. In addition to the paintings inside the Holy City Chapel, the vestibule was painstakingly finished by Malcolm's tile work. She mixed clay from Ardmore to make the tile squares into which she sculpted the Prayer of St. Francis of Assisi. These make up the north wall of the vestibule. Red clay from Denver, Colorado, was used to make the floor tiles, which she formed in the shape of fish scales and, after firing, fitted each together in an interlocking pattern. Her time and talent was donated as a labor of love at no cost to the Holy City. The Holy City Chapel's breathtaking beauty makes it popular for many weddings throughout the year.

The Holy City exists on gifts, donations, and grants. In 1975, the late reverend Anthony Mark Wallock's dream was realized as schoolchildren had generously given their pennies for 30 years to raise the needed money for the *Christ of the Wichitas* statue. As with any city, the need to make repairs and improvements is a constant necessity. Many organizations have generously given grants for this cause. In recent years, these grants have made possible the addition of a large wardrobe building complete with washers, dryers, and sewing machines where the 500 costumes are laundered, mended, and stored. Much-needed modern restroom facilities have also been added. Following many requests by those who used the facilities, a reception room, including kitchen appliances, was provided. A dream that remains on the drawing board is a technologically modern sound room where the pantomiming Bible characters receive their voices. A new museum was welcomed by visitors as many of the original artifacts and pictures had been destroyed by a leaking roof.

Visitors from every state in the union and many foreign countries sign the Holy City Chapel guest book each year. Some visitors make the Holy City of the Wichitas their destination while others find the jewel setting quite by chance. Tour buses frequent the grounds and guided tours can be arranged.

In years past, reports of an attendance exceeding 100,000 people were published. In these days of instant entertainment, the pageant still draws 2,000 to 5,000 spectators to enjoy the longest continually running outdoor Easter pageant in the United States.

During the early years, a cast and crew for the *Prince of Peace* pageant at the Holy City of the Wichitas had 3,000 people taking part. Adjustments have been made as cast numbers have decreased in size. Some volunteers in the cast must portray more than one part while some Bible characters have as many as three people representing them. Animals in the pageant are numerous and necessary. Night rehearsals are challenging for people and animals as each adjusts to moving in the darkness. It presents quite a challenge to be at the right location at the right time.

A large military base, Fort Sill, neighbor to the south, lies between Lawton, the third-largest city in the state, and the grounds of the Holy City of the Wichitas. Many people stationed there visit the grounds and often become cast members during their time at the base. When their families come to visit, the Holy City is the most requested tourist site. As the 84th year approaches, the more than 350,000 visitors to the Holy City grounds each year enjoy what has been called Oklahoma's Oberammergau.

One

THE BEGINNING

Many treasures in a state have started with a dream. Some are fulfilled in a short time; other projects take years to complete.

When Rev. Anthony Mark Wallock accepted the pastorate of the First Congregational Church at Lawton, few could have imagined the young man, although small in stature, had a magnificent dream. Wallock was always drawn to religious drama. In 1926, he and his Sunday school class walked up a privately owned mountain in Medicine Park for a short Easter service. A Resurrection scene was portrayed while a violinist played. Many pledged to return the next Easter for a sunrise service.

During the year, Wallock planned additional scenes. As the program expanded, so did the crowd. The white painted rock representing the tomb was soon replaced with one of rock and mortar. A large white cross marked the Easter service site. A portable organ was carefully carried up the steep path one year. Later the music was provided by community choirs and bands. Electric light lines were strung through the trees and were paid for by the Sunday school class. For the first few years, the softness of distance made the setting effective. As the crowds grew, members of the audience were seated in the scenes. Boy Scout troops volunteered to assist those making the 45-minute arduous climb. In 1933, the Native American girls of Kiowa Indian School dramatized in sign language "The Shepherds Prayer" and "Nearer My God to Thee." Red and green flares flashed, marking the location. As the attendance grew to 40,000 by 1934, visitors had to be turned away. They were out of room.

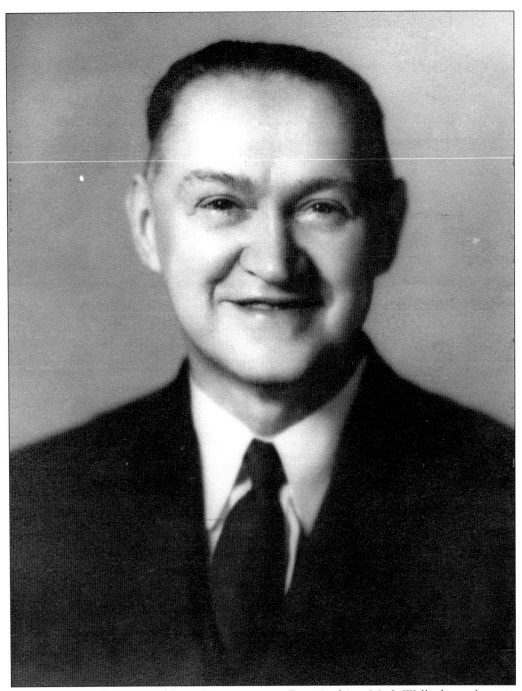

The founder of the *Prince of Peace* Easter pageant, Rev. Anthony Mark Wallock was born in Schildberg, Austria, on April 25, 1890. He and his family immigrated to Chicago when he was two years old. As an adult he studied for the ministry, and after serving several pastorates, he came to Lawton in 1924 to become the pastor of the First Congregational Church. (Wallock Memorial Museum.)

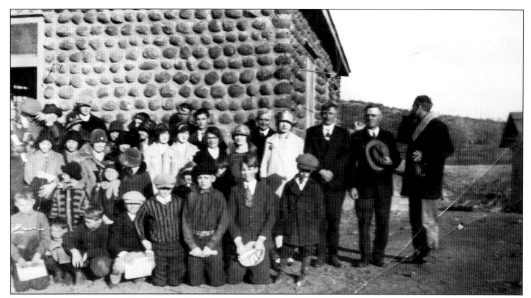

Rev. Anthony Mark Wallock's Sunday school class participated in the first dramatized Easter service on a privately owned mountaintop in Medicine Park in the predawn hours of April 4, 1926. They were asked how many would promise to return next year if possible. Many pledged to do so. (Wallock Memorial Museum.)

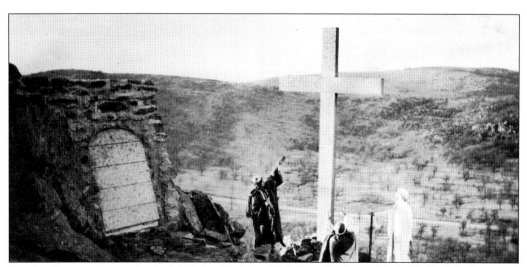

For the first sunrise service in Medicine Park in 1926, Rev. Anthony Mark Wallock had painted a rock to represent the tomb. In 1927, a Sheetrock tomb was built, only to have a spring storm destroy it. Later a tomb of rock and mortar was constructed. It remained as the only permanent structure. (Wallock Memorial Museum.)

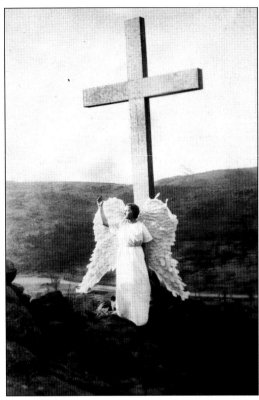

In 1927, a few weeks before the sunrise service date, a large cross was erected on the highest point of the mountain in Medicine Park. It was visible for several miles. On Easter eve, red and green flares were used to mark the location of the service. The steep climb took 45 minutes. Boy Scouts were stationed along the trail to give assistance. (Wallock Memorial Museum.)

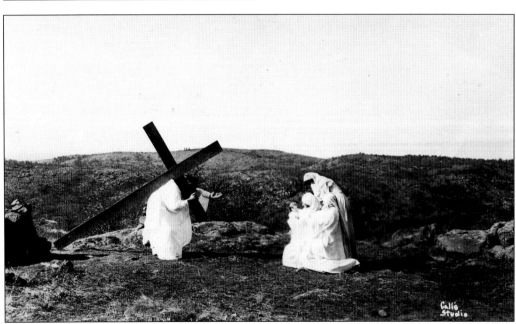

The cross that was used by the actors weighed 125 pounds. Each actor had a very simple costume. The Medicine Park Sunday school class paid for electric lines to be strung through the trees illuminating the path to the mountaintop. The service began with a call to worship by a bugler. (Wallock Memorial Museum.)

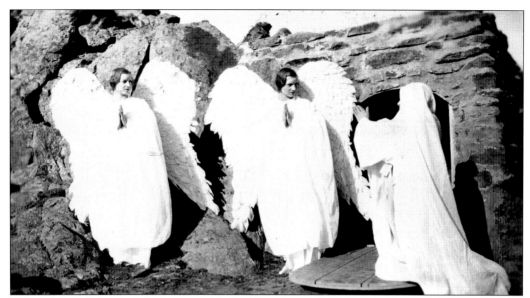

When the women arrived with spices and oils to anoint the body, the angels said, "Why do you seek the living among the dead? For He has risen." As the audience members grew in number, they found themselves seated in the scenes. The service was timed to end just as the sun rose in the east. (Wallock Memorial Museum.)

The door to the tomb fell forward as two angels said the tomb was empty. These two women, identical twin sisters, portrayed this part for many years. In 1939, they were depicted on a postal cancellation showing them at the tomb to commemorate airmail from Lawton. (Wallock Memorial Museum.)

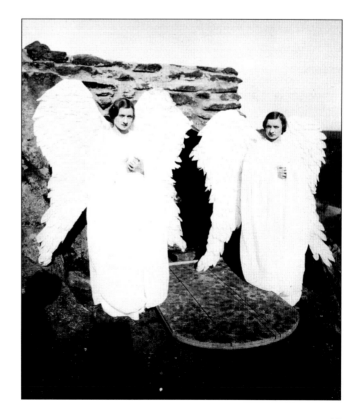

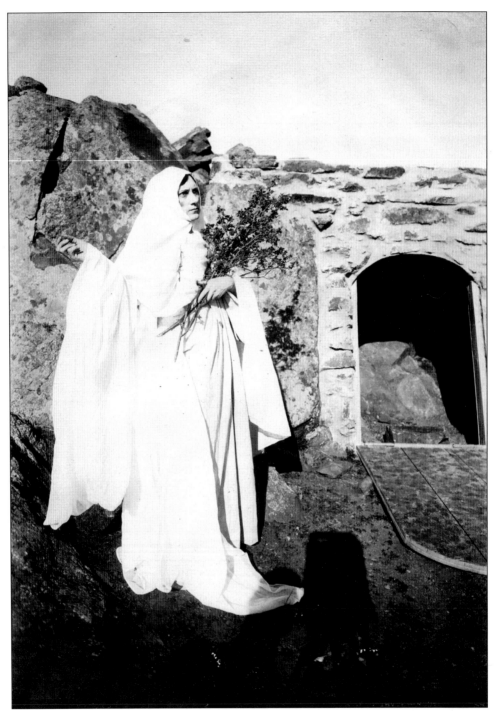

Mary, Jesus's mother, came to the tomb unaware that the rock had been rolled away. Each year, the cast increased as did the audience. Rev. Anthony Mark Wallock used a nearby mountaintop for the portrayal scenes, believing that distance softened the scene and placed emphasis on the story rather than those involved. Handmade paper flowers decorated the mountaintop. (Wallock Memorial Museum.)

In 1933, girls from Kiowa Indian School dramatized in sign language "The Shepherds Prayer" and "Nearer My God to Thee." The music was provided at one service by a portable organ that had to be carried up the steep Medicine Park mountainside. Later a community choir sang as a brass band played. (Western History Collections, University of Oklahoma Libraries.)

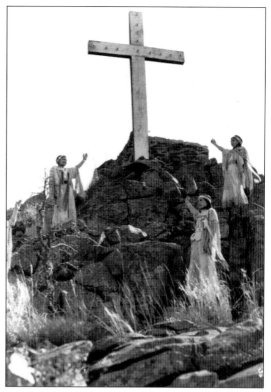

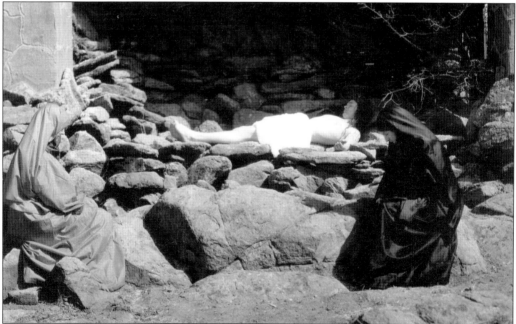

This undated photograph was taken during the early days at Medicine Park. The body of Jesus has been placed in the tomb, but the door has not yet been sealed. Two women keep vigil over the body before the large boulder is rolled into place. (Western History Collections, University of Oklahoma Libraries.)

This rugged terrain is the mountain on which the 1926 Easter Sunrise Service was born. Now it is advised to climb only in the winter months, after rattlesnakes have gone into hibernation and hunting season for deer has closed. Nothing remains of the original set. (Author's collection.)

Two

The Holy City

A question often asked by tour bus passengers or vacationing families, voiced out loud or whispered under their breath, is, "Who built this?" Depending on the age of the inquirer, the initials WPA often suffices. Young history buffs wait for a further explanation. Because of the severe economic times in the 1930s, the Works Progress Administration (WPA) was formed by the United States government. The project gave talented workers in all positions such as artists, musicians, writers, and builders not only a paycheck but a chance to use their abilities. They left lasting beauty in forms of community buildings, parks, stadiums, bridges, and the Holy City of the Wichitas.

Because of Pres. Franklin Delano Roosevelt's interest in reports coming from an outgrown site of an Easter service located in Oklahoma, he made the offer to use 160 acres in the heart of the Wichita Mountains Wildlife Refuge. He also instructed the name "The Holy City" be placed on the file containing reports coming from that location. The name stuck. The Holy City, which is located 22 miles north of Lawton, was assigned 150 WPA workers to build the boulder-clad buildings and facades. The structures are a tribute to the abilities of the engineers and workers as a mild earthquake zone lies to the north, yet after 74 years, they stand exactly as they were built. The half-mile staging area provides a living city setting for the *Prince of Peace* pageant portrayed each Easter. In these days of instant entertainment, the pageant still draws the faithful to participate and an audience of 2,000 to 5,000 people to the jewel in the setting at the base of Mount Sheridan and Mount Roosevelt.

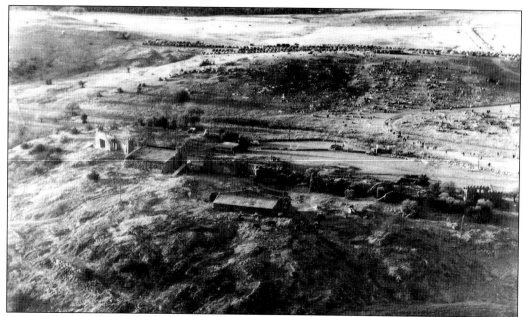

This aerial view facing south shows most buildings finished. At the top of the picture is the parking area with Audience Hill just below. The staging area with buildings and facades runs from east to west across the middle of the photograph. This daytime undated picture could have been a rehearsal or crowds arriving the day before the *Prince of Peace* pageant. (Western History Collections, University of Oklahoma Libraries.)

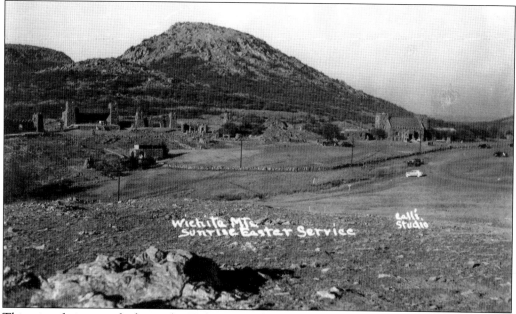

This view facing north shows the Holy City Chapel and Lord's Supper Building on the right. The facades and temple are under construction. The inn, stable, and control center are not yet in place. The rock wall enclosure is visible. The parking area in this photograph is closed during the pageant but is for visitors to the grounds during the year. (Western History Collections, University of Oklahoma Libraries.)

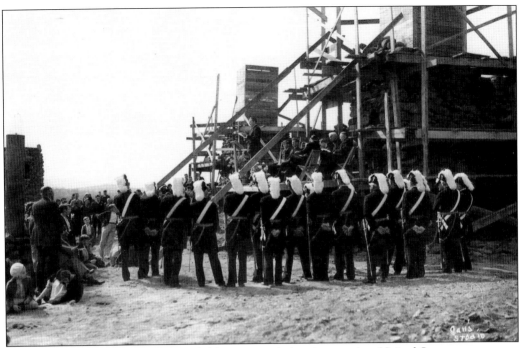

On Sunday, December 20, 1936, at 2:00 p.m. in a dedication service, United States government officials released the Holy City to the board of directors. WPA officials were introduced as well as engineers and supervisors. The Knights Templar took part in this program. Preceding Rev. Anthony Mark Wallock's prayer, a hymn was sung and the doors to the Holy City Chapel were opened. The officials were seated on the raised floor of the building that would become the temple. This building was not yet completed as the wooden structure had not been covered with native stone. At the end of the service, Art Goebel, skywriter, wrote "World Faith" above the $78,000 site. (Western History Collections, University of Oklahoma Libraries.)

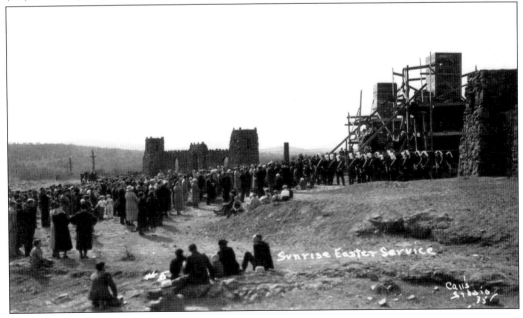

```
WESTERN UNION
```

THE COMPANY WILL APPRECIATE SUGGESTIONS FROM ITS PATRONS CONCERNING ITS SERVICE

CLASS OF SERVICE
This is a full-rate Telegram or Cablegram unless its deferred character is indicated by a suitable symbol above or preceding the address.

R. B. WHITE PRESIDENT
NEWCOMB CARLTON CHAIRMAN OF THE BOARD
J. C. WILLEVER FIRST VICE-PRESIDENT

SYMBOLS
DL = Day Letter
SER = Serial
NM = Night Message
NL = Night Letter
CDE = Code Cable
LC = Deferred Cable
NLT = Cable Night Letter
Ship Radiogram

The filing time shown in the date line on telegrams and day letters is Standard Time at point of origin. Time of receipt is Standard Time at point of destination.

Received at 322 Fourth St., Lawton, Okla. 1936 APR 10 PM 4 49

KMA L19 32 GOVT=SN WASHINGTON DC 10 529P

REV ANTHONY MARK WALLOCK=
 DIRECTOR EASTER PAGEANT

PRESIDENT ROOSEVELT WILL SEND YOU DIRECT EASTER GREETINGS MESSAGE TO BE READ CONNECTION YOUR SERVICES AT HOLY CITY SUNDAY MORNING STOP ARRANGE WITH WESTERNUNION TO SEE THAT MESSAGE DELIVERED TO YOU PERSONALLY=
 ELMER THOMAS.

TELEGRAMS MAY BE TELEPHONED TO WESTERN UNION FROM ANY PRIVATE OR PAY-STATION TELEPHONE

This telegram was sent to Rev. Anthony Mark Wallock on April 10, 1936, by United States senator Elmer Thomas advising him that Pres. Franklin Delano Roosevelt would be sending him a telegram to be read at the Easter service. (Wallock Memorial Museum.)

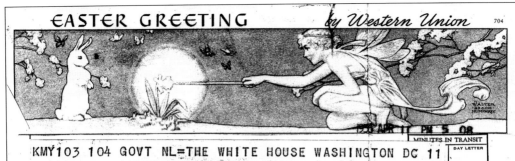

This Easter telegram from Pres. Franklin Delano Roosevelt was delivered to Rev. Anthony Mark Wallock on April 11, 1936. It was read at the start of the *Prince of Peace* pageant on April 12, 1936. With the president's help, the Holy City of the Wichitas became a reality. This photocopy of the telegram is all that remains. (Wallock Memorial Museum.)

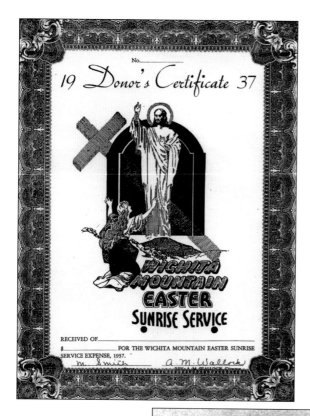

This 1937 donor certificate signed by A. M. Wallock and M. Smith was given to patrons who donated money toward the expenses of the pageant that year. The illustration on the certificate was the same as the front of the program that was given to those in attendance. (Wallock Memorial Museum.)

The week of May 15 through May 21, 1938, National Air Mail Week, the United States Postal Service honored the Holy City of the Wichitas by issuing a postal cancellation depicting two angels outside the empty tomb. The words on the cache, "Wichita Mountains Easter Sunrise Service, Lawton, Oklahoma" commemorated the first airmail service out of Lawton. (Bernard Montgomery collection.)

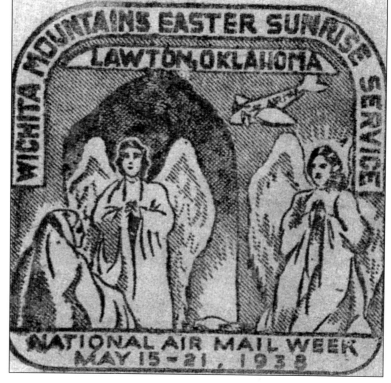

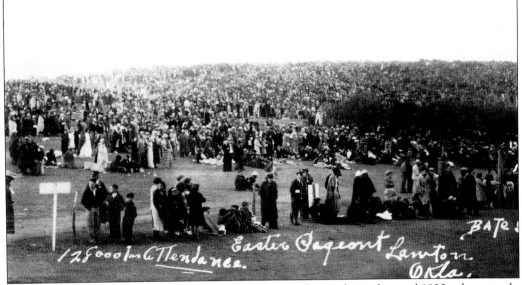

Every inch of Audience Hill appears to be covered with people in this mid-1930s photograph. Those arriving early were fortunate enough to find room to spread a blanket. Three thousand volunteers made up the cast. In the 1930s, not every scene was rehearsed on the pageant site. Out-of-town groups met and memorized their lines and gestures. (Western History Collections, University of Oklahoma Libraries.)

A note on the back of this undated photograph says people were gathering on Friday and Saturday before the 2:00 a.m. Sunday Easter service. The stack of blankets in the foreground indicates these people knew a warm spring daytime in the Wichita Mountains can still mean a very cold night. Warming fires were banned. (Wallock Memorial Museum.)

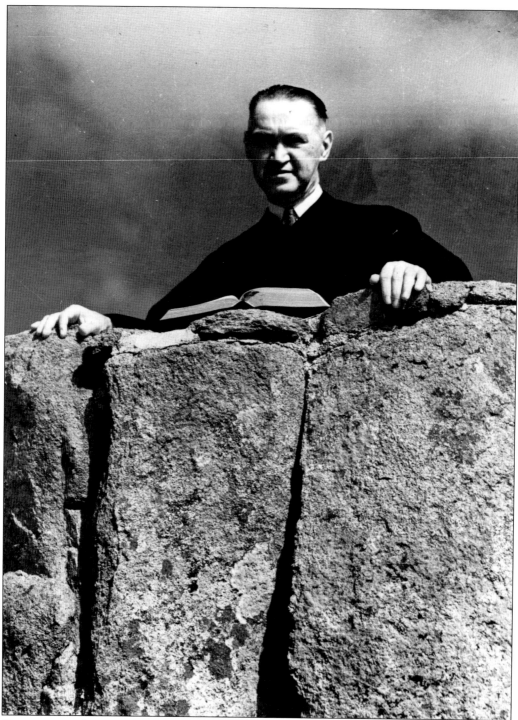

One custom always enjoyed by the volunteers of the *Prince of Peace* Easter pageant was Rev. Anthony Mark Wallock's words to them just before the pageant started. A rock pulpit was built so he could be seen and heard by the 3,000 cast members. It stands today close to the Holy City Chapel as a reminder of his devotion to his flock. (Frieda Sage collection.)

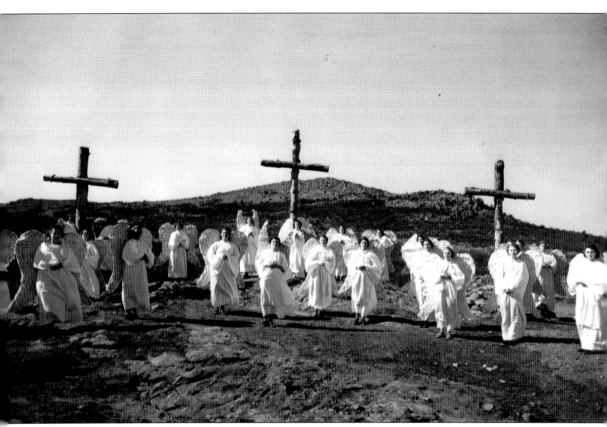

In 1936, Ron Stephens, district WPA director, was told that the sewing room was out of material for angel robes. At his request, many Ku Klux Klan robes were donated. Wallock said, "Something good will come from something that has been bad." For more than 45 years, 400 angels proved that statement true. (Western History Collections, University of Oklahoma Libraries.)

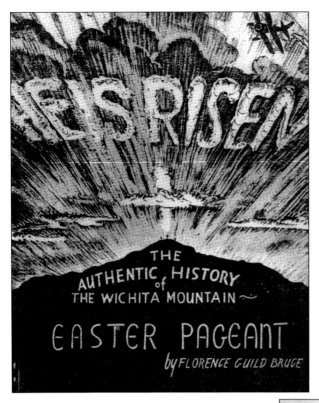

Magazines told the story of the *Prince of Peace* pageant. *Coronet, Good Housekeeping,* and *Collier's* featured either fictionalized stories or had full-color photographs of the pageant. One book was written in 1940 by Florence Guild Bruce titled *He Is Risen*. The book had one printing. A paperback edition was sold at the concession stand during the *Prince of Peace* pageant in 1940. (Author's collection.)

Col. Art Goebel, award-winning pilot and famous ConocoPhillips skywriter, wrote in smoke at the end of the pageant at the Holy City of the Wichitas for more than five years. The first year, 1936, 100,000 people witnessed his amazing feat when he wrote, "He Is Risen." (ConocoPhillips Archives.)

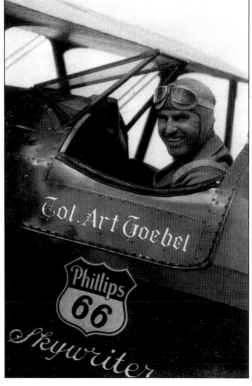

In 1939, Ernie Pyle, roving reporter for the Scripps-Howard news service, wrote a tribute to the *Prince of Peace* pageant for the *El Paso Herald*. "We might say we're going to Lawton this year as we would say 'We're going to Oberammergau.' Things are changing swiftly in the old world. Old sacred things are passing. Maybe Oberammergau is dead and maybe Oklahoma is to carry on." (United States Navy photograph.)

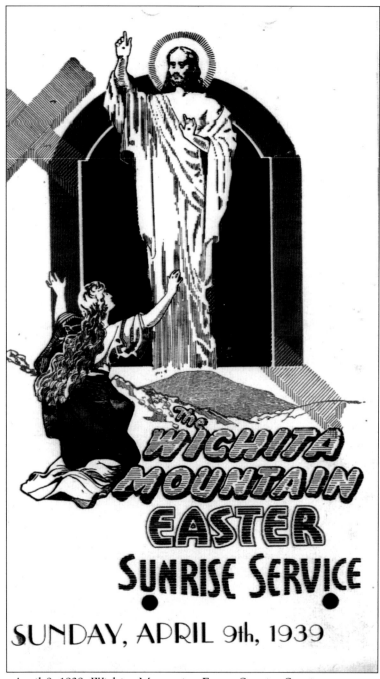

This Sunday, April 9, 1939, Wichita Mountains Easter Sunrise Service program was given to those attending the pageant. Because the service was timed to end at dawn, it was originally called the Easter Sunrise Service. Inside the program is the story of the founder, a brief history of the pageant, and several photographs of scenes, the grounds, and the Holy City Chapel. The chapel was originally know as the Easter pageant music room. Myron C. Groseclose, engineer, compiled the blueprints and protected the plans for the Easter pageant music room. The plans were used by the WPA district No. 7 for the 1936 construction. (Wallock Memorial Museum.)

Aug. 8, 1939

Rev. A. M. Wallock,
Lawton, Okla.

My dear Rev. Wallock,

It is my happy privilege to inform you that the Oklahoma Memorial Association has chosen you as an Oklahoman whose outstanding service and achievements in helping to build Oklahoma and advance humanity entitles you to a place in Oklahoma's Hall of Fame. The Oklahoma Memorial Association sponsors this selection to Oklahoma's Hall of Fame each year for Statehood Day on November 16.

This honor comes to but few. Please acknowledge receipt of this message and your acceptance to be honored. We are inviting you to be our guest at the Statehood Day Banquet on Thursday November 16, 7:30 p.m. at the Oklahoma Builtmore Hotel, Oklahoma City, Oklahoma. During the evening through impressive and proper ceremony you will be inducted into the Oklahoma Hall of Fame.

Your immediate reply will be very much appreciated, together with a Thumbnail biography sketch of your life activities together with a picture for publication in the press. Also please advise us just how you desire your name to appear upon the certificate to be presented to you at this ceremony.

May we caution you not to give out for publication, or to anyone, any information that you have been chosen. We make this request for the reason that we want to give this information to all the papers throughout the State at once, then they will all publish it at one time, while if your local paper gives it out the other papers will likely not publish the story.

Please be sure to state if you can be present for this ceremony because we want to make proper plans.

May I congratulate you upon this honor. We will expect an early reply. With kind good wishes, I am

Most sincerely,

Scott P. Squyres,
secretary

Rev. Anthony Mark Wallock was inducted into the Oklahoma Hall of Fame on November 16, 1939, at 7:30 p.m. in the Oklahoma Biltmore Hotel in Oklahoma City. According to a letter from the Oklahoma Memorial Association, "You as an Oklahoman whose outstanding service and achievements in helping to build Oklahoma and advance humanity entitles you to a place in Oklahoma's Hall of Fame." (Oklahoma Heritage Association Archives.)

The Oklahoma Heritage Association has placed a granite monument plaza at the Oklahoma State Fairgrounds in Oklahoma City. The names of those honored and inducted into the Oklahoma Hall of Fame, the year of their induction, and the area of their contribution is engraved on the stone. Rev. Anthony Mark Wallock was honored in 1939. (Author's collection.)

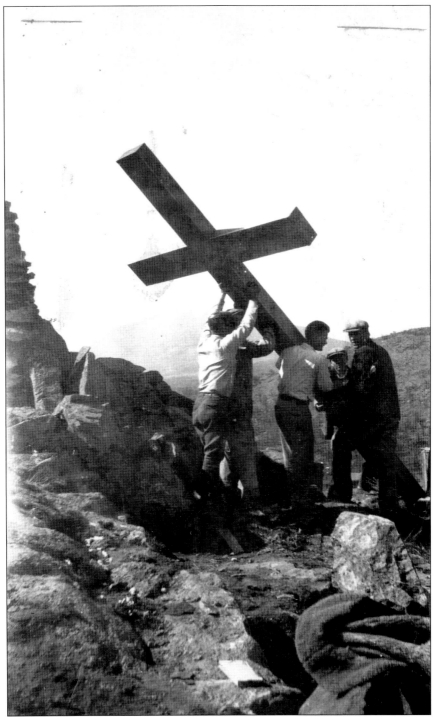

The crew responsible for putting the grounds in order for the pageant places the large lighted cross on top of Audience Hill. The cross at the pageant location has been traditional since the second Easter service that began in Medicine Park, about four miles to the east. (Wallock Memorial Museum.)

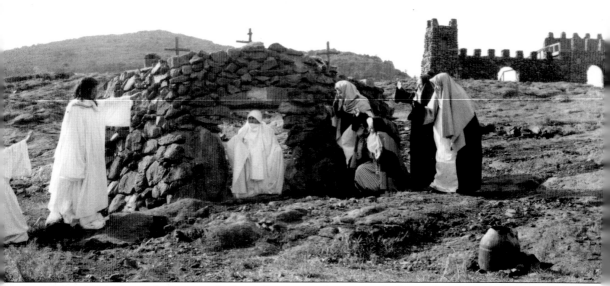

This 1937 rehearsal photograph shows Lazarus in his grave clothes as Jesus commands him to come forth. Jesus turned to Mary and Martha, Lazarus's sisters, and said, "Loose him and set him free." This is the same rock tomb that is in use today. (Wallock Memorial Museum.)

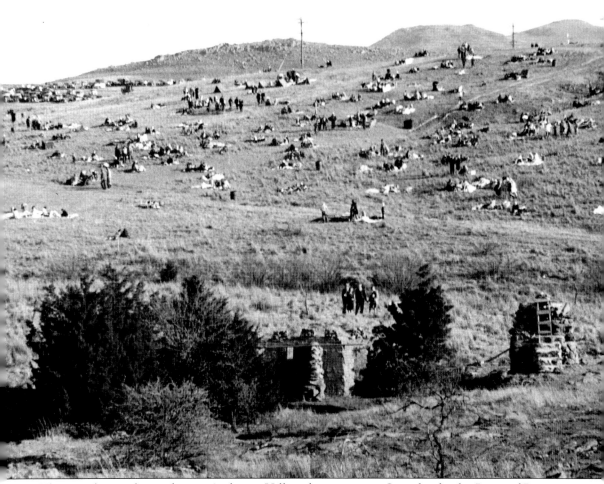

The crowd started to gather on Audience Hill at about noon on Saturday for the *Prince of Peace* pageant that was scheduled to begin at 2:00 a.m. on Sunday. This photograph must have been taken on a mild spring day as most audience members are sitting on their blankets. (Wallock Memorial Museum.)

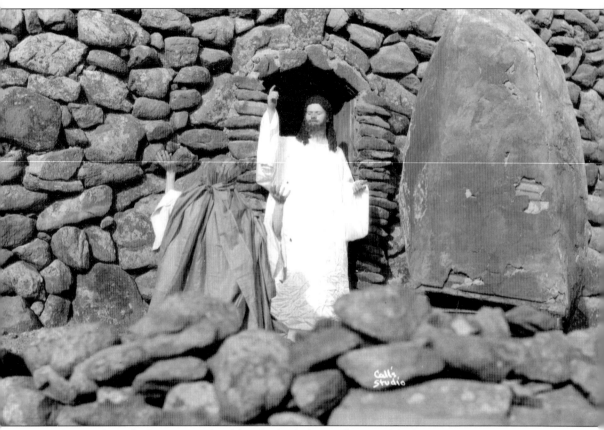

This tomb made from native boulders had a lightweight movable door. One memory that still gives volunteers a smile happened on a cold pageant night. A child angel took refuge in the tomb by way of the back entrance to keep warm and was not discovered until the tomb scene when the stone was rolled away and inside he lay sleeping. (Western History Collections, University of Oklahoma Libraries.)

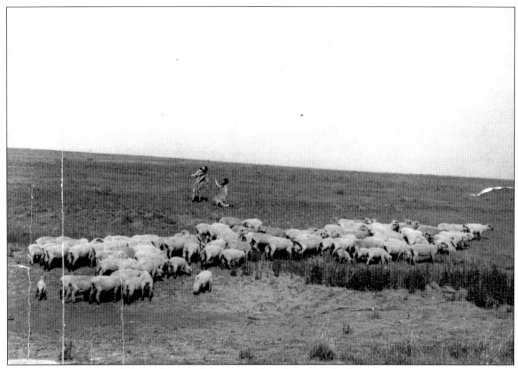

This pageant certainly has plenty of sheep. In the photograph above, the angels are giving the shepherds the good news. This flock is grazing in one of the few flat areas on the grounds as the staging area is rocky and mountainous. The picture below shows the painted figures that must be used when enough live sheep cannot be located. The dim lights of the pageant make this an acceptable flock. (Above, Wallock Memorial Museum; below, author's collection.)

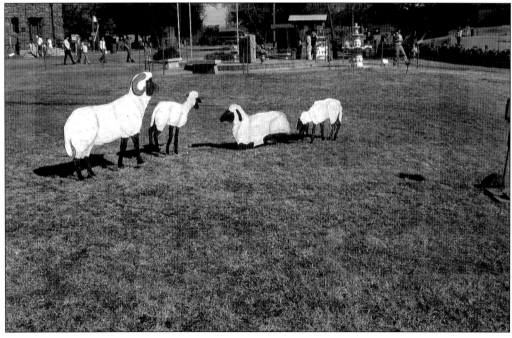

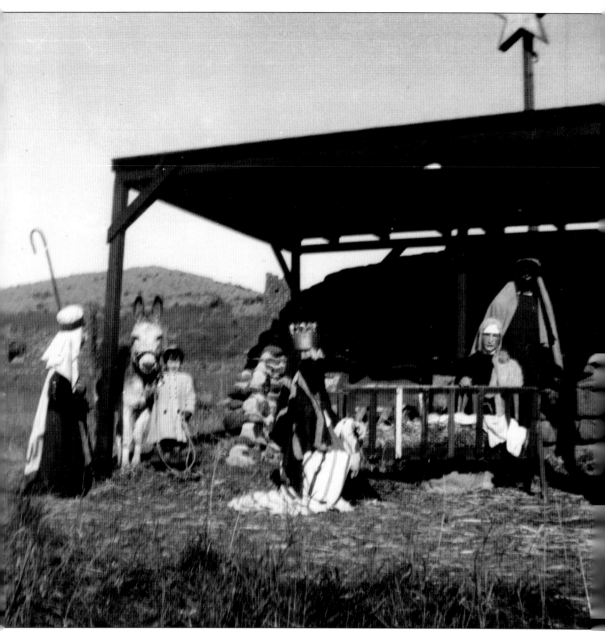
This photograph shows the early wooden stable with the lighted star above. Later it was rebuilt of stone to match the other structures on the pageant grounds. (Wallock Memorial Museum.)

Three

THE CHAPEL

The rugged fortresslike exterior of the Holy City Chapel conceals the beautiful and intricate interior. Lawton artist Irene Malcolm spent seven years turning the bare walls and ceiling into breathtaking beauty. It is a setting for many weddings during the year, sometimes more than one on the same day. Into the vestibule wall tile she sculpted the Prayer of St. Francis of Assisi:

> Lord, make me an instrument of Thy Peace. Where there is hatred, let me sow love; where there is injury, pardon; where there is doubt, faith; where there is despair, hope; where there is darkness, light; where there is sadness, joy. Oh, Divine Master, grant that I may not so much seek to be consoled as to console; to be understood as to understand; to be loved as to love; for it is in giving that we receive. It is in pardoning that we are pardoned, and it is in dying that we are born to eternal life.

Because of the rocky setting, a long-whispered rumor accepted by most was that the space beneath the Holy City Chapel floor was home to uncountable numbers of rattlesnakes. The area was always avoided until the inevitable happened—a repair was necessary. A call was made to a business specializing in all rodent control. The time was set and an ambulance was on hand. Rangers from the Wichita Mountains Wildlife Refuge arrived to assist. A rope was secured, assuring a way back to the opening if the worst happened. The employee descended through the small opening in the chapel floor, flashlight in hand. Topside, all was silent as spectators held their breath. Finally a voice was heard in the distance: "No snakes down here . . . not even a spider!" Visitors often ask, "Got any snakes out here?" Yes, they live among the boulders but not in the beautiful Holy City Chapel.

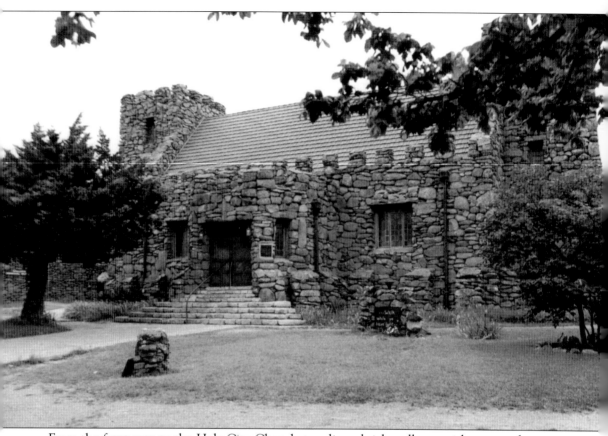

From the front gate to the Holy City Chapel steps lies a brick walkway with engraved names of friends of the Holy City. The pathway continues to the east and west from the chapel. The cornerstone, located between the door and stained-glass window reads, "Enter into his gates with thanksgiving and into his courts with praise." (Wallock Memorial Museum.)

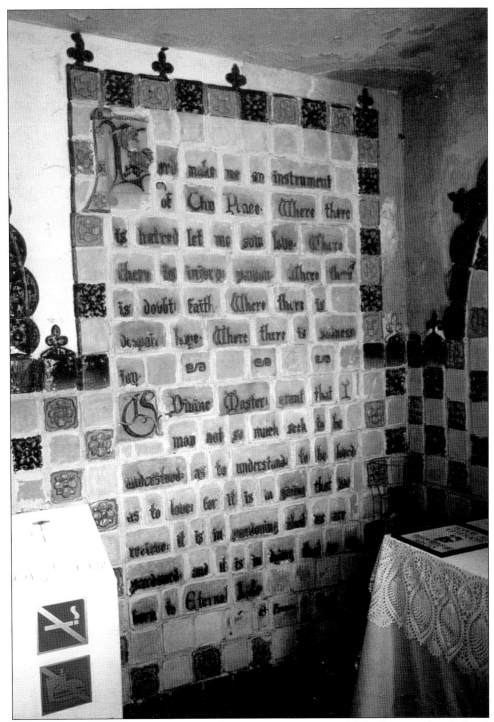

In 1953, after seven years of intense work, Lawton artist Irene Malcolm completed the floor and walls of the vestibule in the Holy City Chapel. The clay was mixed for the 1,000 floor and 1,500 wall tiles and then fired by Malcolm. On the north vestibule wall engraved in the tile is the Prayer of St. Francis of Assisi. (Author's collection.)

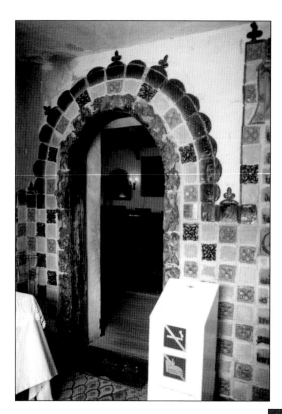

The doorway into the Holy City Chapel is framed with a tile archway of purple grapes, green leaves, and brown stems. The clay for the wall tiles came from Ada. The floor is tile made of red clay from Denver, Colorado. Recesses in the east and west walls hold faceless statuettes of Christ healing the lame and blind. (Author's collection.)

On a hot August weekend in 1952, a workday was called at the Holy City. Irene Malcolm had been working for some time on the Holy City Chapel tiles. She made and fired them in her kiln at her home. She was out of room. A wooden structure on the north edge of the Holy City was finished in rock and became her workroom. This building is now known as the Angel House. (Author's collection.)

Irene Malcolm, portrait and mural artist, was a Lawton native. She graduated with a degree in botany from the University of Oklahoma. She then studied fine arts at the Colorado Springs Fine Arts Center. She also studied privately with Leonard Goode, Oklahoma University art instructor. She turned down dozens of commissions and teaching assignments to finish the interior of the Holy City Chapel. This is her self-portrait. (Wallock Memorial Museum.)

On the Holy City Chapel platform, on either side of an archway behind the pulpit, are two child-size angels. These were also done by Irene Malcolm as part of her chapel adornment. (Author's collection.)

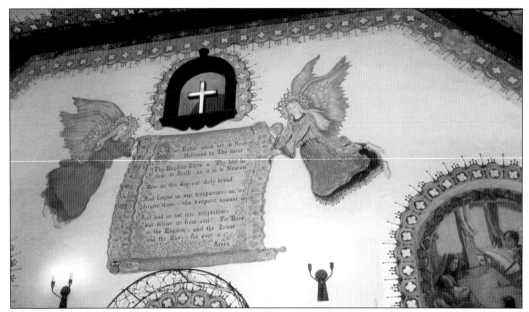

Behind the lectern, two angels hold the Lord's Prayer scroll. The small cross is in the window of Rev. Anthony Mark Wallock's upstairs study. Most of Irene Malcolm's artwork was done on portable art board that she completed in her small studio in downtown Lawton. These angels and scroll are painted directly on the plaster chapel wall, making it very fragile if repairs are needed. (Wallock Memorial Museum.)

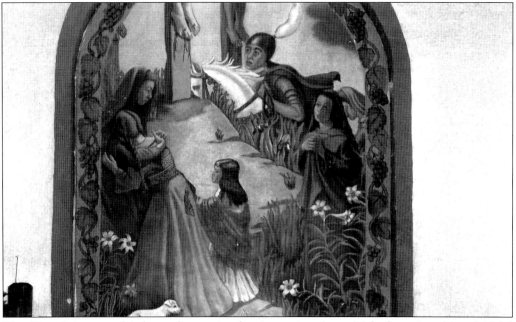

The Crucifixion mural is located opposite the Ascension. Irene Malcolm painted her faithful little dog into the lower left corner. The paintings on the ceiling have never needed repair; however, a leaking roof caused damage to the back and front walls that required extensive restoration. Workmen carefully matched the paint around the murals but left the beautiful artwork untouched. (Jonna Lowry collection.)

In 1968, one visitor, Bill Hoegger, toured the Holy City Chapel on a summer vacation. Something about the niches seemed familiar to him. He received permission to get a closer look. His suspicions were confirmed. They were Kohler bathtubs. Hoegger had worked at the Kohler plant as an electrician. He found the bathtubs dated 1927 and numbered. They were four-foot Colonna models. The cast-iron tubs had been cut in half and placed with the cut edge down to form a niche. In the photographs three are visible with two near the ceiling and one below the Christ Child painting. Each holds a religious figure. No record was kept of who may have made the donation to the Holy City Chapel or who might have had the novel idea. (Author's collection.)

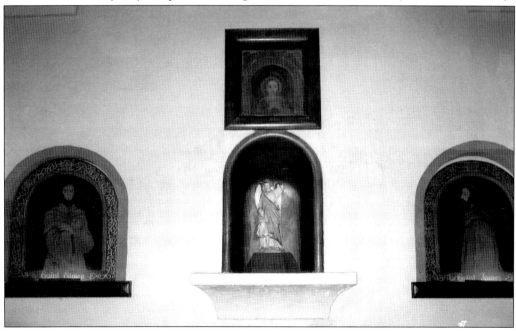

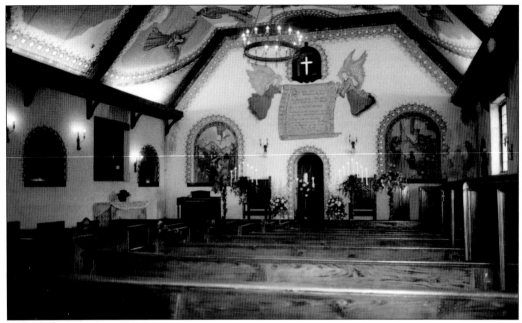

This view from the back shows the crown-shaped chandelier with candle bulbs. The indirect lighting gives a soft glow to the Holy City Chapel's interior. The wooden pews are gated on each end. The nondenominational chapel has never been used as a site for regular services but is open to the faithful of all beliefs. (Author's collection.)

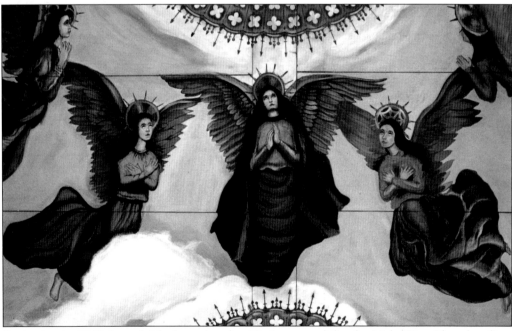

Beginning in 1945, Irene Malcolm painted a 60-piece mural for the Holy City Chapel ceiling. Surrounded by a medieval-type border, angels hover in a boundless blue sky dotted with white clouds and doves. Niches in the walls hold paintings of the 12 apostles. Malcolm said her intent was to depict the personality of each apostle, especially to make Judas appear weak. (Author's collection.)

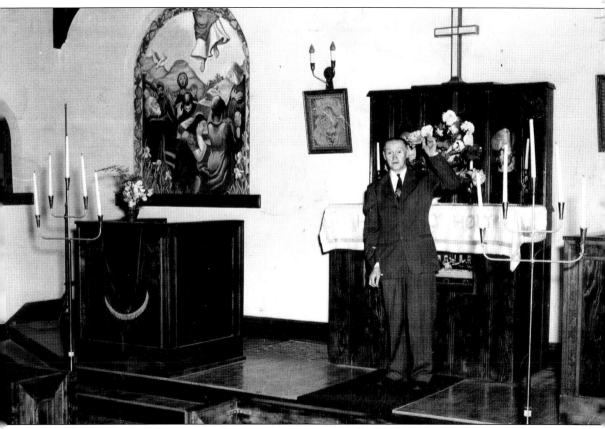

Rev. Anthony Mark Wallock is shown at the front of the Holy City Chapel. Some of Lawton artist Irene Malcolm's paintings are visible at the front. The Ascension mural in the arch is located to the left of Wallock. Malcolm talked at length with Wallock about his dreams for the chapel's adornment. Following his death in 1948, Malcolm continued her project four more years. (Wallock Memorial Museum.)

This sign that now hangs in the Wallock Memorial Museum is a reminder of days past when the Holy City Chapel was not air-conditioned. The caretaker had to be sure that ropes were secured across the opening to the vestibule as the burros that lived on-site loved the cool chapel interior. (Author's collection.)

This painted wood template, one of several now displayed in the Wallock Memorial Museum, was designed and painted by Irene Malcolm. These were placed around arches and pictures in the Holy City Chapel until the painting on the actual walls was done. Now this beautiful artwork is above doorways in the Wallock Memorial Museum. (Author's collection.)

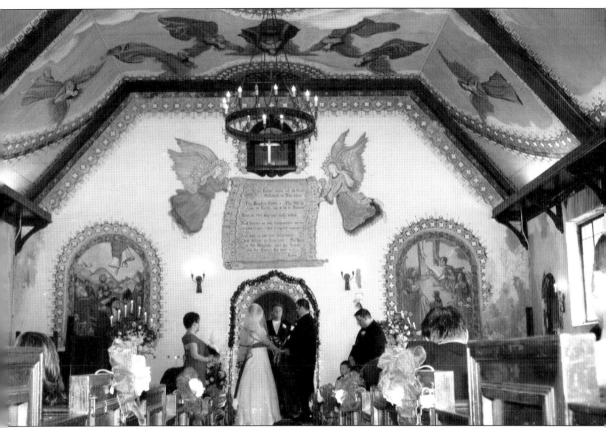

The Holy City Chapel is frequently used for weddings, both large and small. Sometimes more than one wedding in a day is held there. After many requests, a reception room with a small kitchen was added, making a complete wedding arrangement available. (Treasured Memories by Staci.)

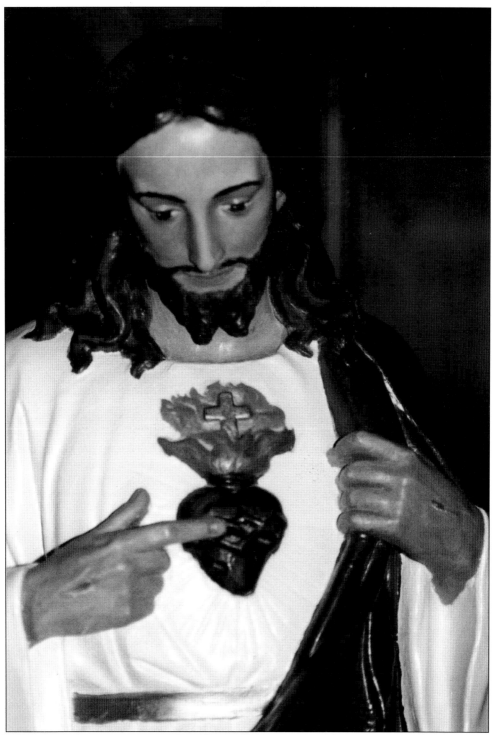

The large *Sacred Heart* statue stands in the southwest corner of the Holy City Chapel. Although it is nondenominational, because of the interior design and the many decorative figures inside, it is often mistaken for a Catholic chapel. (Author's collection.)

Four

The Film

The film company Hallmark Productions (no connection with the Hallmark Cards of today) approached Rev. Anthony Mark Wallock with an offer of producing a film featuring the *Prince of Peace* Easter pageant. Thinking of the opportunity to have the pageant known around the world, Wallock accepted the offer. The film, *The Lawton Story*, was made in the tradition of Hollywood. A make-believe family in Lawton had its life changed because of the pageant. The *Prince of Peace* portion of the film was photographed on the grounds of the Holy City of the Wichitas. Those portraying the pageant were drawn from the actual cast. The film was reviewed by the *Hollywood Reporter* and *Variety* magazines as well as hundreds of newspapers around the world. The film had its premiere in Lawton at two theaters, the Ritz and the Lawton, on the night of April 1, 1949. Sitting governor Roy J. Turner greeted dignitaries as they arrived in Lawton. Rev. Anthony Mark Wallock was seriously ill by the time the film was finished and passed away on December 26, 1948, before its release.

The legal understanding was that after the film's world tour, the Holy City would receive both the film and rights to it, along with the agreed upon $100,000 payment. After a considerable period of time, the legal obligations had not been met. A judge ordered the film be returned to the Holy City along with the $100,000. The film was returned, cut into pieces, and the monetary amount was never realized.

The movie tin containing 60,000 feet of film sat on a shelf for years. An interested person happened upon the story and with knowledge of computer technology offered to see if the 90-minute film could be restored. After much work, he successfully retrieved the pageant section of the film. He passed away before the legal papers could be signed to give the Holy City rights over the film. It is once again in the court system while the Holy City awaits a judgment.

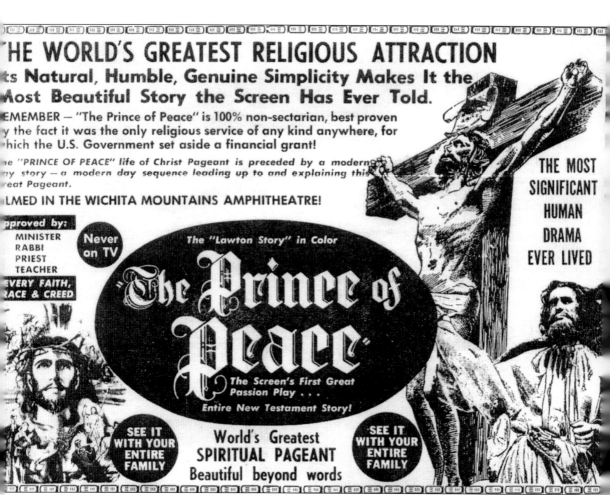

Handbills were distributed and posters were placed in store windows in Lawton to advertise the upcoming film production *The Lawton Story*. At the premiere, it was announced the film would be shown Easter Sunday morning, April 17, 1949, before dawn in New York City's Central Park. (Wallock Memorial Museum.)

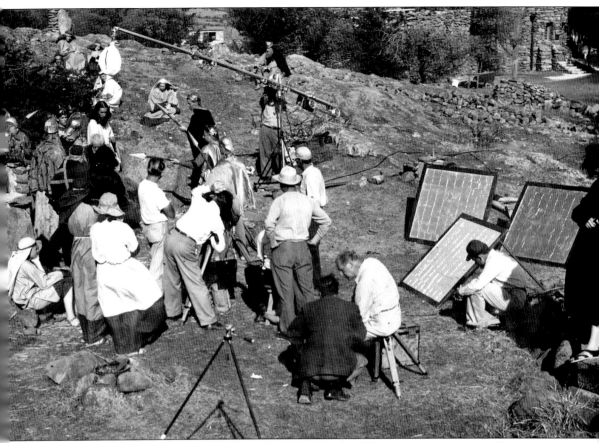

"Lights, camera, action" was caught in this photograph of the pageant portion of *The Lawton Story* being filmed at the Holy City of the Wichitas. Everyone seems to be in their places as Jesus enters the scene from the garden area. (Wallock Memorial Museum.)

INVITATION — ADMIT ONE — WORLD PREMIERE
"THE LAWTON STORY"
Friday Evening, April 1st, 1949, Promptly at 8 P. M.
RITZ THEATRE
"GOLDEN RULE HONOR SECTION"

A Special Reserved Section for the Largest Financial Supporters of the Easter Service Association. This performance by Invitation Only. No Admission charged.

(Signed) REECE L. RUSSELL, Secretary.

No. 046 — This Invitation must be presented ONLY at—RITZ THEATRE

The Lawton Story premiered on April 1, 1949, in Lawton at two theaters on the same evening. The Ritz and the Lawton had identical programs on that night. The gold tickets were given to patrons for a $1,000 donation, the largest financial supporters of the Easter Service Association. These seats were for the "Golden Rule Honor Section." The Easter Service Association never received payment. (Wallock Memorial Museum.)

OFFICIAL RECEIPT
$5.00

This acknowledges receipt of a $5 donation to the Wichita Mountain Sunrise Easter Service Association, as a contribution toward the future expense of said Association.

(Signed) REECE L. RUSSELL, Secretary

Invitation — ADMIT ONE — World Premiere
"THE LAWTON STORY"
COLORED BALCONY
Ritz Theatre, Lawton, Okla., Friday, April 1st
Doors Open 7:30 P. M. ● Performance promptly at 8 P. M.

The Bearer is invited as a Guest of the Wichita Mountain's Association for the World Premiere of "The Lawton Story." Presentation of this ticket at the door of the RITZ THEATRE guarantees the bearer a seat. Said performance is by invitation only and is private, since no admission is being charged.

(Signed) REECE L. RUSSELL, Secretary

No. 10 — This Invitation must be presented ONLY at—RITZ THEATRE COLORED BALCONY

Tickets to *The Lawton Story* were given for a $5 donation. This is a pink ticket for a general admission to the full-length Cinecolor film. After viewing the movie, many people were anxious to visit the Holy City grounds. Printed on the ticket is the statement "This acknowledges receipt of a $5 donation to the Wichita Mountain Sunrise Service Association, as a contribution toward the future expense of said Association." The Easter Service Association never received the promised money. (Wallock Memorial Museum.)

Advertising photographs were placed outside theaters where the movie was showing. These same pictures were also included in a booklet containing facts about the pageant within *The Lawton Story*. The paper booklet was sold as a program at the theaters. It could also be mail-ordered for $1 each, including postage. (Wallock Memorial Museum.)

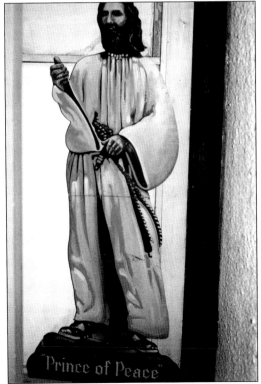

A seven-foot cardboard image advertising the pageant portion of *The Lawton Story* featured Millard Coody, Lawton banker, in the role of Jesus. This was used in the lobby or on the sidewalk in front of the movie theater. It is one of the few items salvaged and resides in the Wallock Memorial Museum. (Wallock Memorial Museum.)

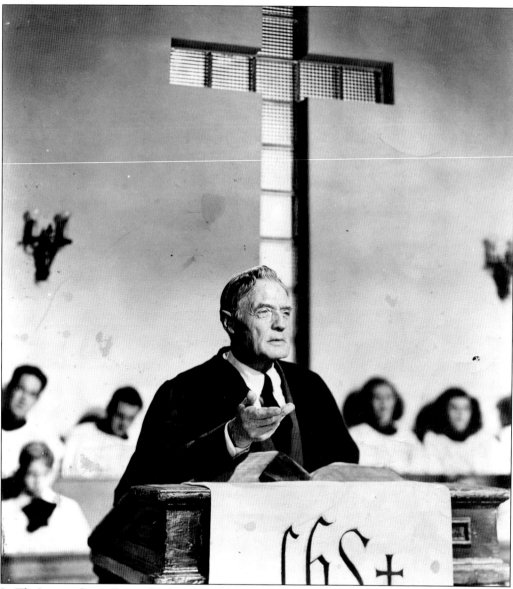

In *The Lawton Story*, Forrest Taylor plays the part of Rev. Anthony Mark Wallock. In the program booklet sold at the film's premiere, a comment is made that Wallock was "the little minister who carried the Bible in his head." Wallock was not in the pageant portion of the film. (Wallock Memorial Museum.)

Early in the pageant portion of the film, Mary and Joseph arrive at the Bethlehem Inn only to find it has no room. The courtyard is also full of people. Through the years, countless animals have been provided by local residents. Some are very agreeable; however, a few decide to quit when startled by sudden light changes. (Wallock Memorial Museum.)

The producers of *The Lawton Story* felt that long after the theater showings, the film would be shown in churches for years. Many times descendants of someone who had a part in the film were anxious to see their family members. A few VHS versions were sold in the gift shop until they were no longer obtainable. (Wallock Memorial Museum.)

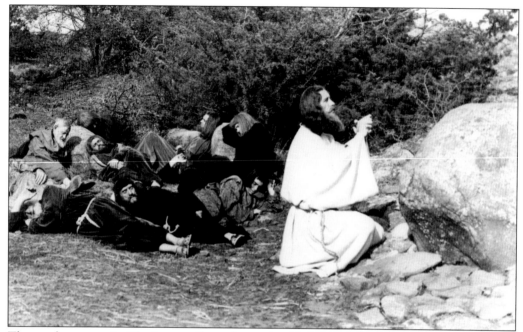

The garden scene in *The Lawton Story* shows the 12 disciples sleeping while Jesus prays. In their advertising, the filmmakers always mentioned that they used the best color film available: Cinecolor. When the film was edited, the producers objected to the Oklahoma accent. The finished film was released with dubbed voices. (Wallock Memorial Museum.)

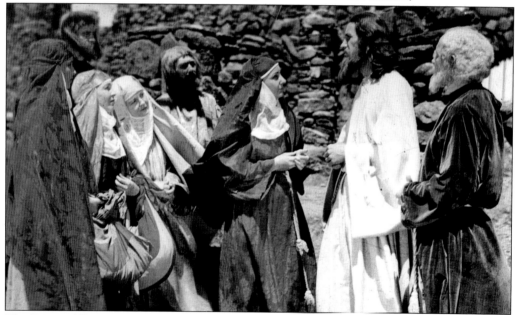

The *Prince of Peace* pageant as well as the pageant part of *The Lawton Story* drew from the large all-volunteer cast at the Holy City. Producers of the film said approximately 3,000 volunteers from Lawton and nearby towns had some part in the film. Only Millard Coody was identified. The tradition has always been that the pageant volunteers who participate are known only as cast members. (Wallock Memorial Museum.)

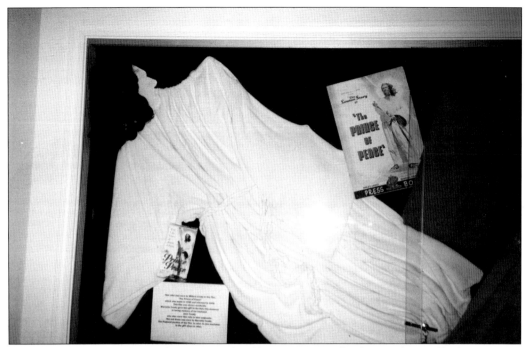

The robe that Millard Coody wore in the film is now on display in the Wallock Memorial Museum. It is made of heavy linen fabric. The disciples in the film were also members of the Easter pageant cast. When Hollywood wardrobe assistants dressed them, their simple costumes were replaced with velveteen robes. (Wallock Memorial Museum.)

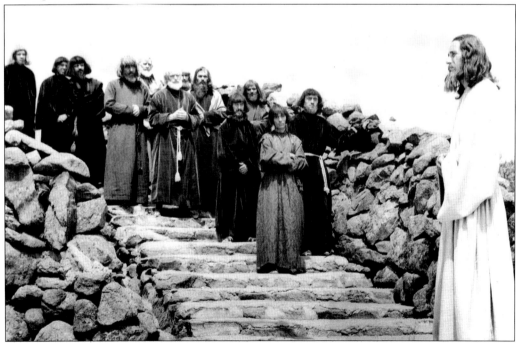

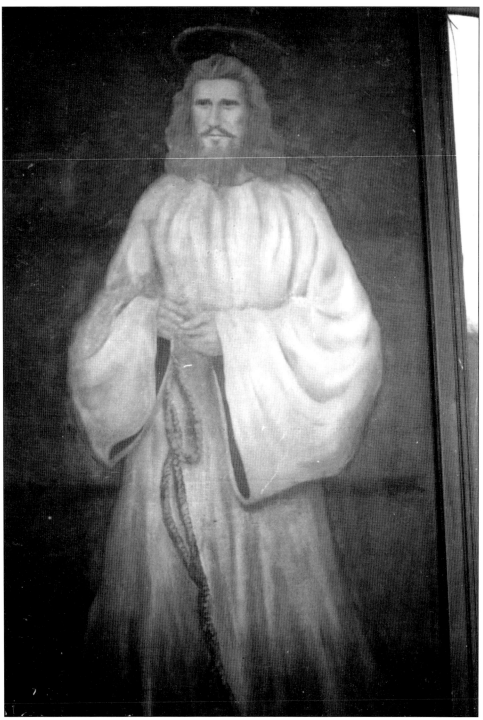

The paper booklet sold at the showing of *The Lawton Story* contained a certificate to be filled out and mailed to register to win a life-size oil painting of Jesus. This painting is at the Holy City and may have been given as a gift to the Wallock Memorial Museum. The artist is not named. (Wallock Memorial Museum.)

Five

THE STATUE

On a bright autumn day at 2:30 p.m. on November 9, 1975, at the Holy City of the Wichitas, the long journey for the *Christ of the Wichitas* statue was at last realized when it was unveiled and dedicated. The idea for the statue had started more than 30 years before. It had been the dream of the founder of the Holy City and *Prince of Peace* pageant, the late reverend Anthony Mark Wallock. It was one desire not completed when Wallock died on December 26, 1948. The journey had been long, not only for the white marble statue from the quarries in Carrara, Italy, but for the faithful who collected pennies and dimes for nearly 35 years until the purchase was possible. Several attempts were made to collect the $9,675 needed to bring the statue to reality. Most failed, or at best collected only a small amount. Children started the effort that succeeded with their pennies delivered to the hostess at the Holy City. A sign saying, "Site of Christ of the Wichitas" had been placed on the rocky bluff and lighted on pageant night. On August 19, 1975, the 12-foot-tall figure was delivered to Lawton. A granite pedestal that was quarried in southwestern Oklahoma was prepared on the site. On October 25, two trucks arrived at the Holy City. One vehicle carried the 12,000-pound statue. The second truck was a crane capable of lifting it into place. A stone from Mount Olive, near Jerusalem, was embedded into the base. After several speakers, 1,000 spectators joined the Salvation Army in singing. It was a long time coming but more than worth the wait.

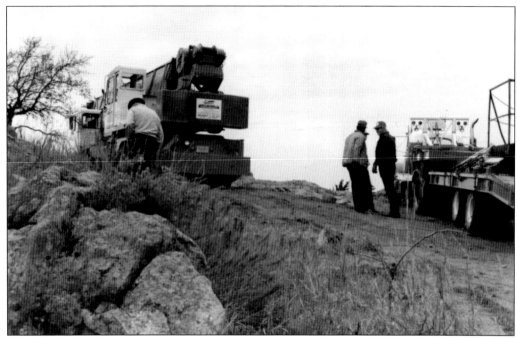
On October 25, 1975, two trucks arrived on the Holy City grounds at the site of the statue. One contained the tarpaulin-wrapped statue. The other truck held a crane strong enough to lift the 12,000-pound *Christ of the Wichitas* statue. The total price was $7,550. (Frieda Sage collection.)

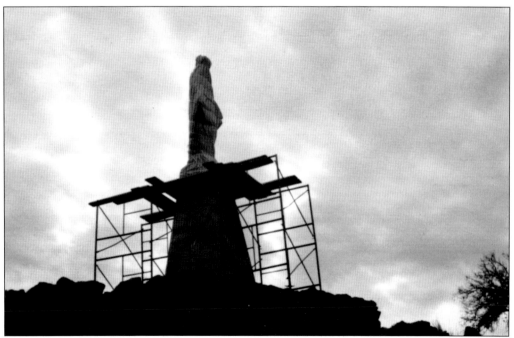
The *Christ of the Wichitas* statue was set atop its pedestal and remained shrouded in a heavy wrap until it was unveiled at the dedication ceremony on November 9, 1975. The scaffolding is in place for the application of the native stone that will cover the pedestal. (Wallock Memorial Museum.)

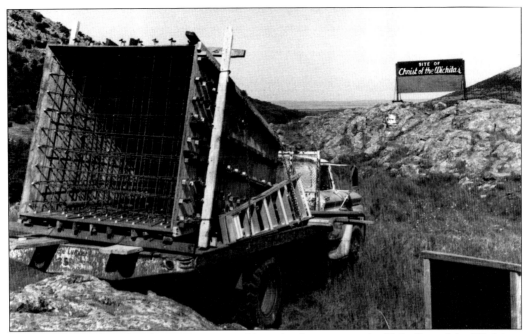

A truck delivered the four-foot-square tapered base for the statue to the Holy City of the Wichitas. The site was chosen by the late Anthony Mark Wallock. A sign at the location read, "Site of Christ of the Wichitas." It was lighted at pageant time to encourage interest. Rock for the veneer covering of the base was quarried in southwest Oklahoma. (Frieda Sage collection.)

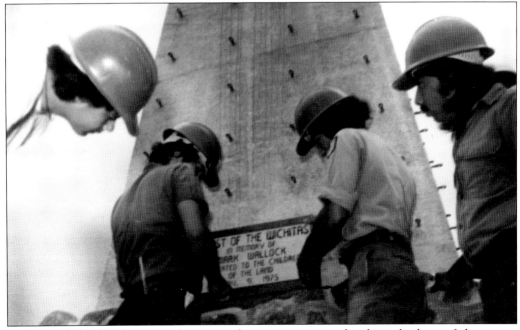

Workmen held the plaque in place as rock veneer was completed on the base of the statue. The Wallock Foundation Board of Directors was pleased the statue was set on the bluff without moving one stone on the landscape. The plaque reads, "Christ of the Wichitas in memory of Mark Wallock. Dedicated to the children of the land. Nov. 9, 1975." (Frieda Sage collection.)

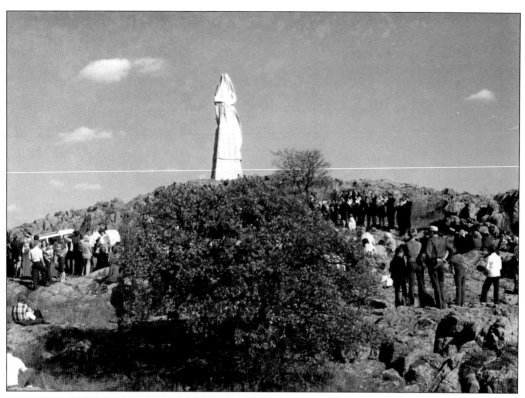

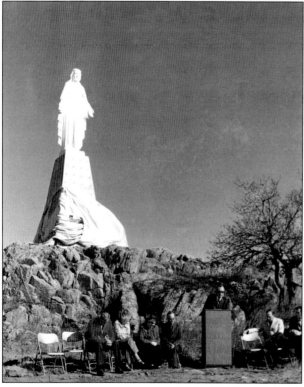

Sunday afternoon, November 9, 1975, the white marble *Christ of the Wichitas* statue was dedicated. After speeches and songs, the 1,000 spectators watched as it was unveiled. The *Sunday Oklahoman* on August 3, 1969, had printed an article by roving reporter Ernie Pyle that said, in part, "A great figure of Christ on a nearby peak will dominate the turrets, domes, and towers of Oklahoma's Holy City." (Wallock Memorial Museum.)

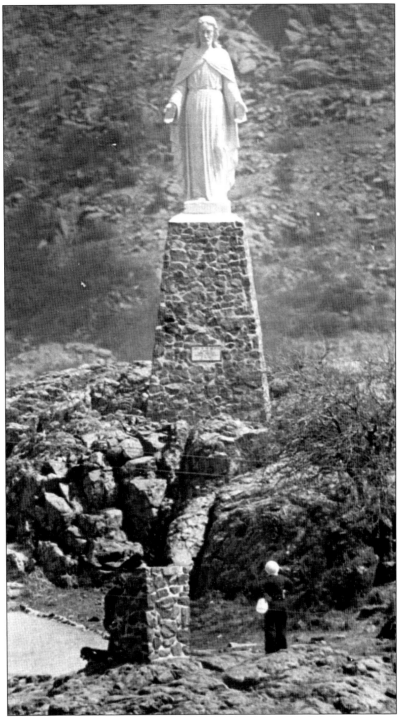

A visitor standing on ground level shows the size of the *Christ of the Wichitas* statue. The 12-foot statue stands atop a 14-foot pedestal. The rock monument in the lower center holds an engraved metal sheet containing names of committee members responsible for the details involved in securing and setting the statue. (Frieda Sage collection.)

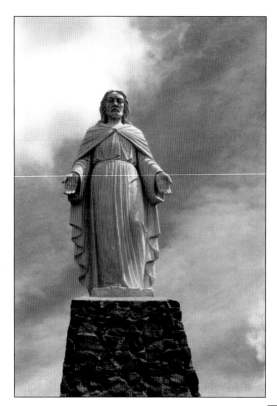

Not long after one enters the Wichita Mountains Wildlife Refuge on Highway 49, the *Christ of the Wichitas* statue becomes visible to the north. It is nestled in a valley with a backdrop of Mount Sheridan and Mount Roosevelt. Its immense size makes it visible on the entire approach to the Holy City. The statue is not meant as an object to worship but as a source for thought. (Wallock Memorial Museum.)

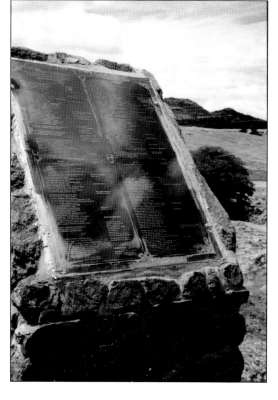

This rock veneer monument matching the pedestal stands in front of the *Christ of the Wichitas* statue. A brief history is engraved on the metal plaque detailing the years of struggle involved in obtaining the statue. It also contains the names of businesses, organizations, and major individual contributors. (Wallock Memorial Museum.)

Six

The Grounds

When the Holy City of the Wichitas is mentioned, many immediately say, "The Easter pageant." This is correct; however, the Holy City of the Wichitas grounds are a destination for more than 100,000 visitors the other 11 months. The buildings were designed and built as not to disturb the beautiful natural setting. Many historical sites are tucked away on the grounds, some obvious, some in need of an explanation. The Holy City of the Wichitas shares 59,000 acres with animals who call the Wichita Mountains Wildlife Refuge home. The buffalo and longhorn cattle have grown accustomed to the humans who pass through, but rangers warn that they are wild animals. At rehearsal time, the increased activity on the Holy City grounds usually means a herd of buffalo arrives to investigate. The caretaker on his motorized cart, holding a noise shaker, discourages it from attending. The rock wall enclosure is but a mere step for the animals to explore the pageant grounds. A small building, the control center that gives the cast members their voices, is glass enclosed on the north. A longhorn steer, either dissatisfied with his reflection or protecting his territory, hooked his horn in one of the four-by-eight-feet sections of glass paneling and pulled it out. A thornbush from Jerusalem, a gift to the late reverend Anthony Mark Wallock, grows in the yard. Close by is a granite monument celebrating Myron C. Groseclose, who designed the Holy City setting. Buses arrive bringing visitors, and conducted tours can be arranged. Hollywood could never compete with the beautiful natural setting that is the Holy City of the Wichitas.

The first marker on Highway 49 after taking exit 45 indicates the Holy City's location. Before entering the Wichita Mountains Wildlife Refuge, the highway skirts a small, quaint setting known as Medicine Park, the birthplace of the *Prince of Peace* pageant. The homes and buildings of native cannonball rock have been a tourist destination for many years. It is still home to both permanent residents as well as those who enjoy a quiet summer getaway. (Author's collection.)

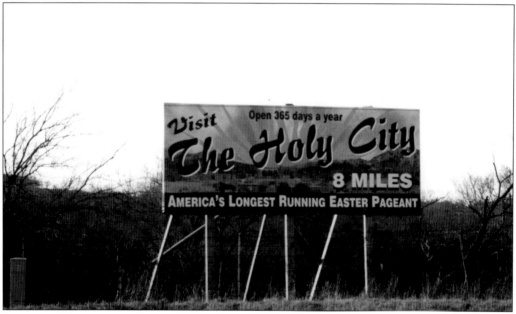

Signs are a very important part of advertising. This roadway billboard invites guests to visit the Holy City of the Wichitas. The Wichita Mountains Wildlife Refuge estimates that 100,000 people visit the Holy City each year, not counting those attending the annual *Prince of Peace* pageant. Inside the Wichita Mountains Wildlife Refuge, small markers direct travelers to the Holy City in what might be a confusing setting. (Author's collection.)

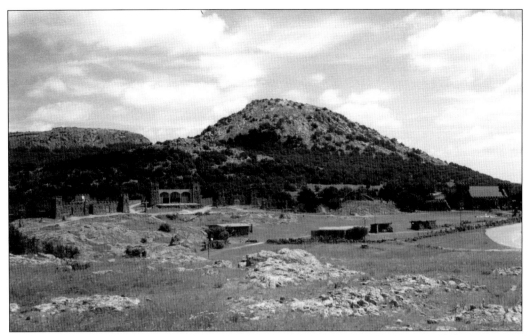

The half-mile staging area blends with the natural landscape of the Holy City of the Wichitas. From the Holy City Chapel on the far right to the three crosses on the hill, the entire course is a walk back in time. The Holy City is open 365 days a year from 8:00 in the morning until 30 minutes before sundown. (Author's collection.)

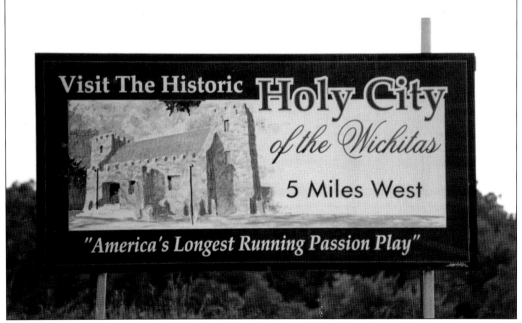

This artist's rendering of the Holy City Chapel at the Holy City of the Wichitas was enjoyed by travelers for years. A dispute over permission from a nearby landowner to place the billboard resulted in its being taken down and left in the tall grass. The winter weather destroyed the artwork. (Author's collection.)

The rock wall enclosure is not meant to be a fence but merely marks the *Prince of Peace* pageant grounds. Just inside, stretching from the entry gate to the west, is the Veterans' Walk of inscribed bricks and tablets. Some of those honored have been cast members in the past, and others are cast members now. Many were connected with the Fort Sill U.S. Army post when they became involved with the Holy City. (Author's collection.)

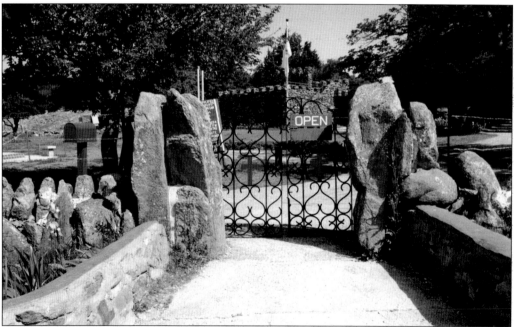

A wrought-iron gate welcomes visitors to the Holy City of the Wichitas grounds. The serene, peaceful atmosphere makes one's visit a pleasure. Whether a guided tour has been planned or a few hours of quiet meditation is spent in the Holy City Chapel, a day at the Holy City is not to be forgotten. (Author's collection.)

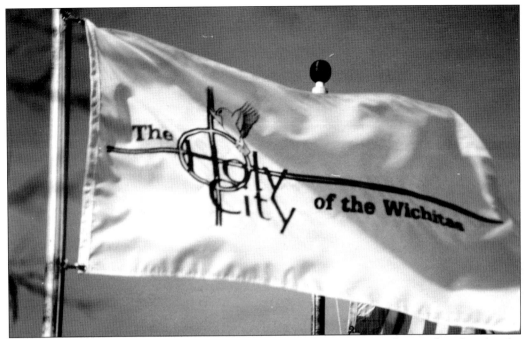

The Holy City of the Wichitas's flag flies just below the American flag in the plaza by the wrought-iron entry gate. The logo bearing the name, cross, and dove is used on stationery, stickers, and clothing. It was adopted in the mid-1990s. (Author's collection.)

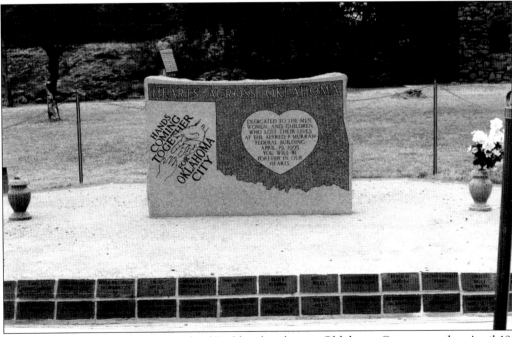

After the tragic Alfred P. Murrah Federal Building bombing in Oklahoma City occurred on April 19, 1995, a Lawton group called Hands Coming Together for Oklahoma City secured the necessary funds for a memorial remembering those who were killed. Names of those lost in the event are engraved on bricks encircling the state-shaped granite monument. (Author's collection.)

Near the entrance gate is a small shrublike tree. Most of the year its green leaves and low branches go unnoticed. In early spring, delicate white flowers with a citrus fragrance cover the bush. This thorn bush, brought from the Holy Land as a seedling, was a gift to Rev. Anthony Mark Wallock. Its five-inch thorns, capable of puncturing an automobile tire, give new meaning to the crown of thorns. (Author's collection.)

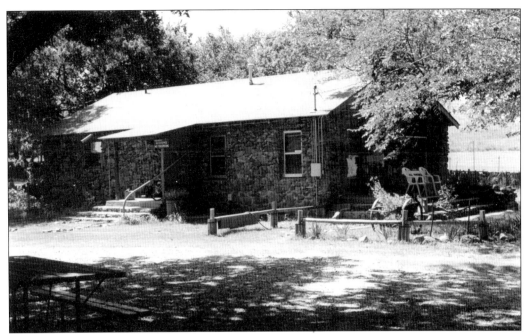

This rock home built for Rev. Anthony Mark Wallock was his only request. A large window on the front gives a view of the Holy City grounds. A plaque embedded in the rock by the front door reads, "A. Mark Wallock, founder of the Easter Pageant." It has been the home of the required on-site caretaker since Wallock's death. (Author's collection.)

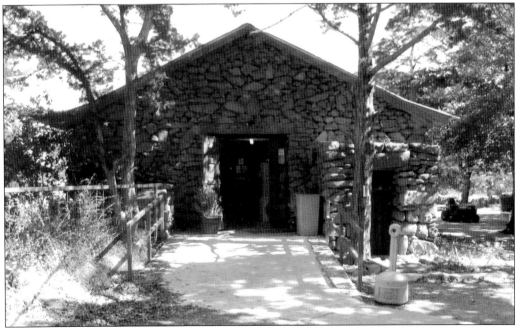

The gift shop, one means of support for the Holy City, is housed in a small rock building that was Rev. Anthony Mark Wallock's first home. The shop is handicapped accessible, as are the Holy City Chapel and Wallock Memorial Museum. It is open daily and where picture postcards as well as shirts and caps with the Holy City logo are popular items. (Jonna Lowry collection.)

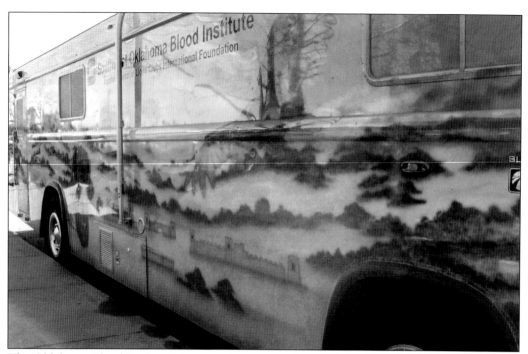

The Oklahoma Blood Institute's Lawton donor center honored the Holy City of the Wichitas by having its buildings and landscape painted on one of its mobile coaches. As it travels the southwestern counties of Oklahoma, it is a constant source of advertising. (Jonna Lowry collection.)

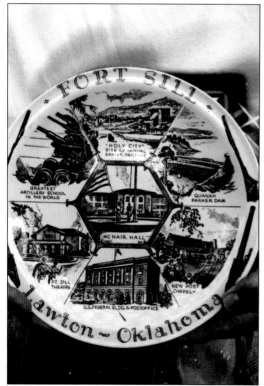

This plate was a popular tourist collectible marked "Fort Sill, Lawton, Oklahoma." In addition to some well-known landmarks, a picture of the Holy City is at the top center. Fort Sill is a neighbor to the south of the Holy City grounds. It is not only helpful, but often its service personnel are cast members. (Author's collection.)

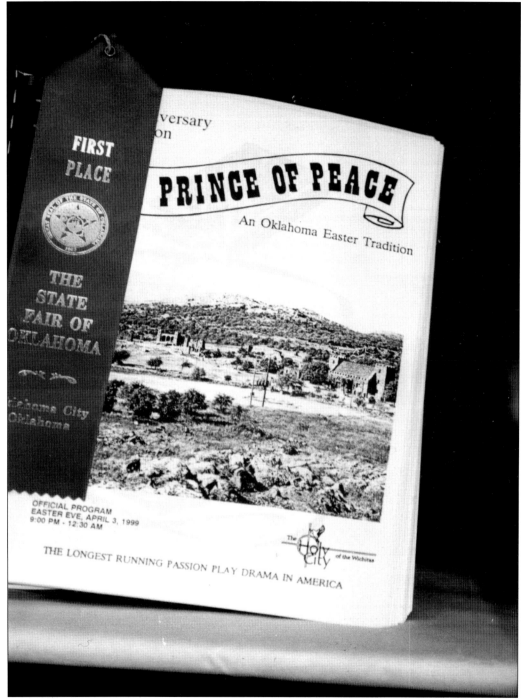

The compiled history book titled *The Holy City of the Wichitas 1926–1999* was entered in the Oklahoma State Fair. The *Lawton Constitution* and the *Daily Oklahoman* gave permission to copy and use their articles from the faded microfilm stored in the Oklahoma Historical Society newspaper room. Their articles written in the language of the day are the bridge in history from its 1926 start until now. The book won a blue ribbon. (Author's collection.)

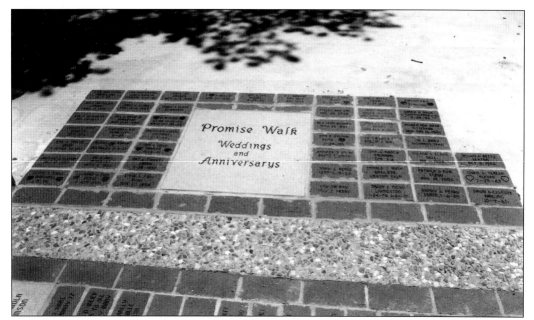

A very popular item that can be ordered in the gift shop is an engraved brick. Although several placement locations are available, the Promise Walk commemorating weddings and anniversaries receives a lot of attention. The purchaser receives a certificate when the brick is set, making it the perfect gift for a loved one married in the Holy City Chapel or to note an important date. (Author's collection.)

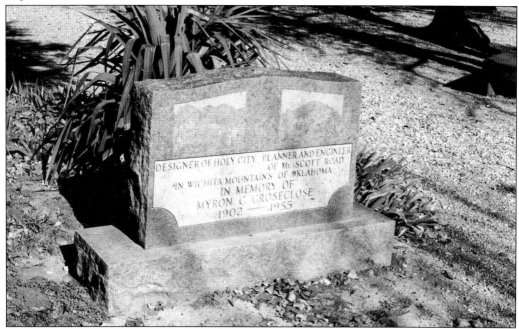

A granite monument on the grounds celebrates the life and achievements of Myron C. Groseclose, the designer of the Holy City of the Wichitas. He was a graduate of Oklahoma University. Groseclose said, "The Holy City is the only religious project in the United States being completed with government funds." (Author's collection.)

Only two United States of America WPA 1936 markers can still be found on the Holy City of the Wichitas grounds. The entire venture at the Holy City is the only religious project undertaken, built, and paid for by the United States government, with the approval of Pres. Franklin Delano Roosevelt. (Author's collection.)

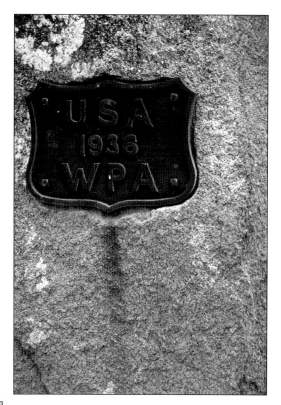

This rock pulpit was built for Rev. Anthony Mark Wallock. He was a man of small stature and used this to speak words of encouragement and appreciation to the cast of 3,000 or more volunteer participants of the *Prince of Peace* pageant. This WPA structure is located near the Holy City Chapel. (Author's collection.)

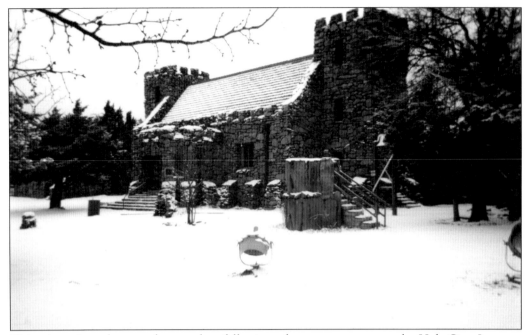

This wintertime photograph was taken following a heavy snowstorm at the Holy City. It serves as a quiet time before the flurry of activity in preparation for the pageant, the birth of buffalo calves, and the blooming of the many flower bulbs. The grounds and gift shop remain open regardless of the weather. (Wallock Memorial Museum.)

This cedar tree planted more than 60 years ago was located in front of the Holy City Chapel. It was included in artwork of the chapel on tourist objects such as cups and plates. Lightning struck the tree, making removal necessary. A friend of the Holy City, an accomplished wood turner, made a beautiful vase from the trunk, which is now on display in the Wallock Memorial Museum. (Author's collection.)

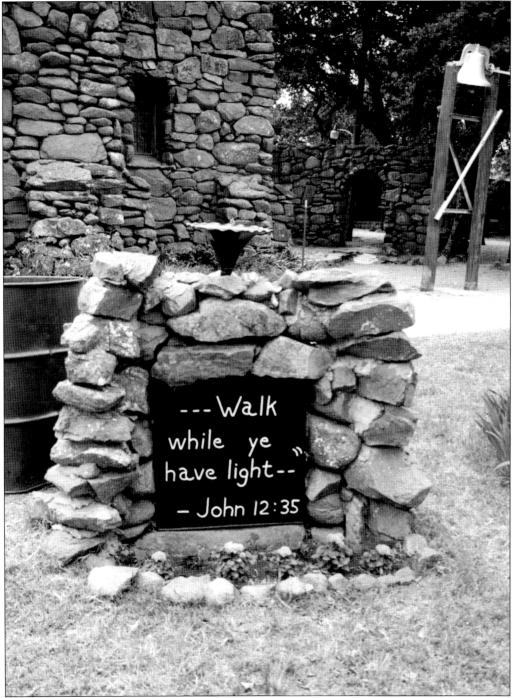

A small group witnessed the lighting of the eternal flame on December 25, 1966. The memorial was a gift from an anonymous family long associated with the Holy City. A favorite verse of the founder, Rev. Anthony Mark Wallock, from John 12:35 is inscribed on the black metal base: "Walk while ye have light . . ." The eternal flame is located near the Holy City Chapel entrance. (Author's collection.)

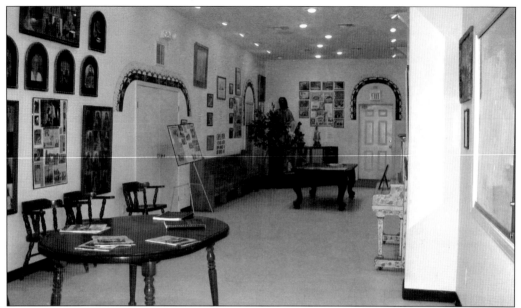

The new Wallock Memorial Museum, located on the Holy City grounds, is an area that is climate controlled. This was made possible by a very generous grant from the McMahon Foundation. The original museum was located on the ground floor of the Lord's Supper Building that is used in the pageant. A leaking ceiling went unnoticed for a length of time and destroyed most of the early historical pictures. After much restoration and searching for items, the modern Wallock Memorial Museum contains most of the Holy City's past. In the photograph below, dressed mannequins represent the cast. Glass cases contain several gifts made to the Holy City. An audio loop is activated upon entry, explaining the items and pictures around the room. (Author's collection.)

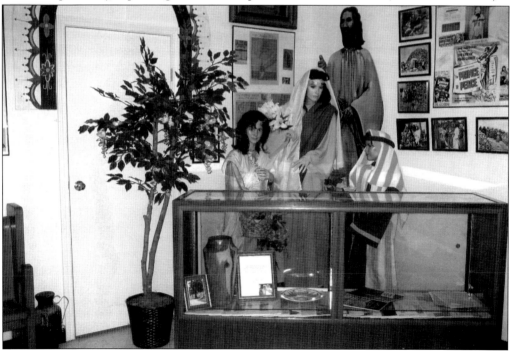

When the Wallock Memorial Museum was dedicated, Channel 7 television based in Lawton was there. The McMahon Foundation members were special guests as their generous grant helped make this climate-controlled room possible. (Author's collection.)

The mannequins in the Wallock Memorial Museum are representative of cast members in the *Prince of Peace* pageant. Many visitors enjoy sharing stories of attending the pageant with their church groups or family members. The weather is usually mentioned as a vivid memory. Lightning is the one element that, when it occurs, the grounds must be cleared for. The rocky terrain is iron rich and attracts it. (Author's collection.)

The Burros — Little Crossbearers —
Hagar (and Sheba, has her baby) are both
expecting offspring at any time.
In fact, according the best esti-
mate, they are overdue.
If you would like to guess when
the event may occur, write your
name and address on that date
in the calendar, circling the hour? A
date for Hagar and one for Sheba.
Sheba has the white star in her face.
Also suggest names for the babies, preferably Biblical.

The burros that lived on the grounds were very popular with visitors to the Holy City. The caretaker posted this sign about Sheba and Hagar. Children enjoyed guessing the date of birth and picking a biblical name for the baby burros that were expected. The sign now hangs in the Wallock Memorial Museum. (Author's collection.)

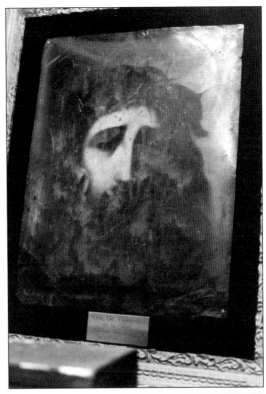

Veil of Veronica is an oil-on-copper painting by an unknown Spanish priest from the early 1800s in Mexico. The plaque reads, "Gifted to the Holy City 2001 by Edwin Lewis Dunn, Jr." It is enjoyed by visitors to the Wallock Memorial Museum, where it is displayed. (Author's collection.)

On the 80th anniversary (2005), the Holy City of the Wichitas received proclamations of congratulations from Brad Henry, governor; Don Armes, representative; Randy Bass, state senator; and James M. Inhofe, United States senator. Recognition was entered into the Congressional Record of the United States Senate noting the 80th year. The Comanche County Board of County Commissioners issued a proclamation celebrating the 80th anniversary. (Author's collection.)

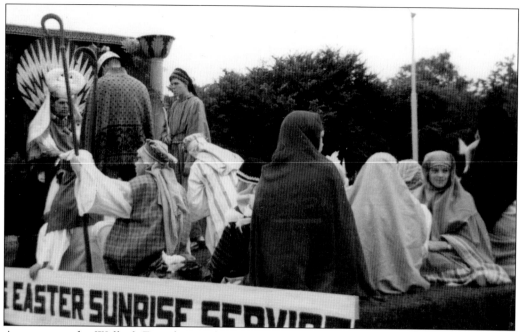

At one time the Wallock Foundation, formerly known as the Easter Sunrise Association, took part in a yearly parade in Lawton. The scene was staged on a flatbed truck. On its door was a sign giving the name of the scene. The Holy City won so many awards that in the last few years it did not compete but only participated. (Wallock Memorial Museum.)

Shown in glass cases on the Wallock Memorial Museum wall are many of the trophies the Holy City has won for its parade floats. The center frame is the original certificate of incorporation for the Holy City of the Wichitas. (Author's collection.)

This native stone bell tower, located at the southeast corner of the Holy City Chapel, was constructed by the WPA in the 1930s. It is commonly assumed the bell was rung to call cast members together. (Author's collection.)

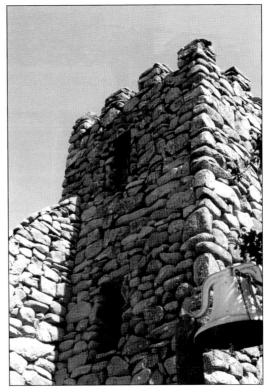

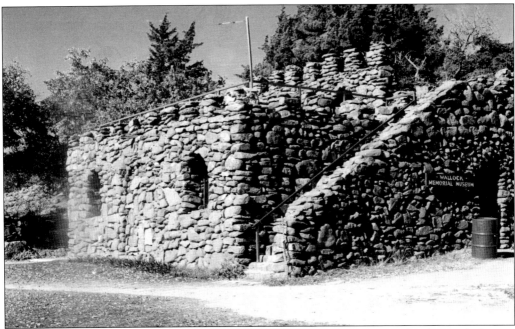

Jesus and the disciples use the upper portion of this building as the setting for the Lord's Supper scene. This permanent structure is located just to the west of the Holy City Chapel. The lower room housed the first Wallock Memorial Museum, but a leaking roof made the move to the new location necessary. (Author's collection.)

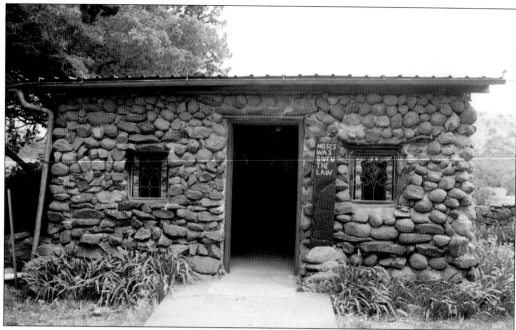

In 1965, another major project was completed. The Moses House was designed and built by Col. Jack Rhodes, retired, and two assistants. The building, pictured above, is constructed of native stone to match the other structures on the grounds. This rock building is located between the Holy City Chapel and the Lord's Supper Building. Although it is not used as part of the pageant, it serves as a costume-changing station. Below, the Moses House holds costumed mannequins in a diorama portraying Moses as he descended from Mount Sinai after receiving the tablets containing the Ten Commandments. A few months before his death in December 1965, Rhodes, longtime pageant worker and executive producer, recorded his reading of the Ten Commandments, which played for many years as visitors entered the building. (Author's collection.)

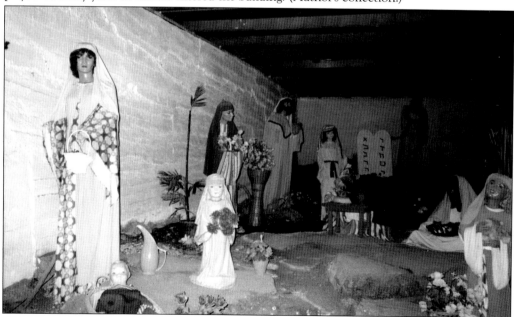

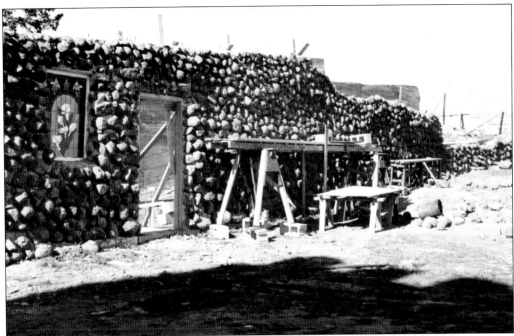

The native stones are being placed on the Moses House as it is under construction in the photograph above. One stained-glass window has been set. This building remains a primary donation site for offerings left for the Holy City. These offerings are essential to sustain the Holy City and help pay for the bills that are incurred. The Moses House now contains the scene of Moses and the children of Israel as the Ten Commandments are received. In the photograph below, above the partially rocked wall of the Moses House, the back side of the Lord's Supper Building is visible. (Wallock Memorial Museum.)

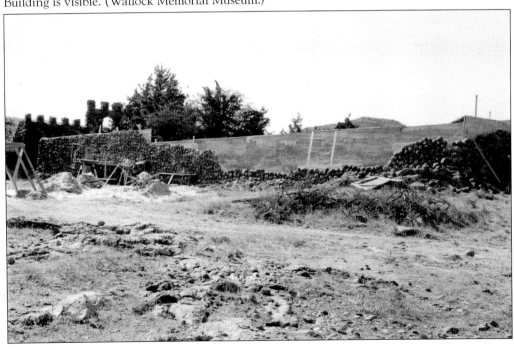

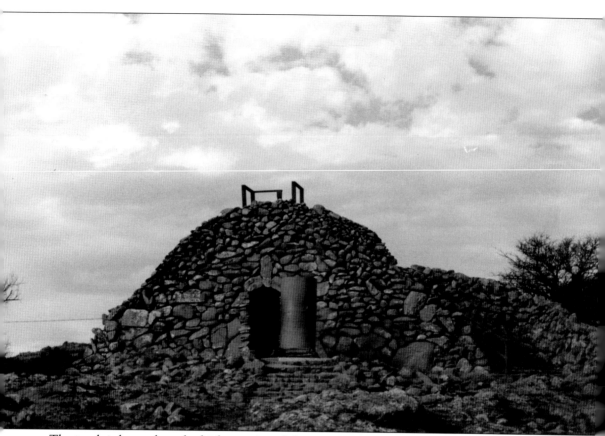

The tomb is located on the highest point of the staging area. Spotlighted in the dark of night, the scene is both sad and beautiful—sad when the rock door is sealed shut, beautiful when it is shown to be empty. A back doorway allows cast members to come and go and many times has tempted some to seek a warm shelter. (Author's collection.)

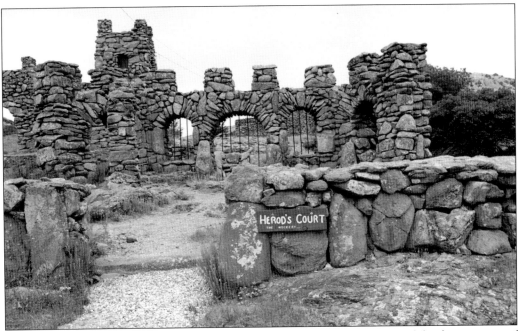

Herod's Court is another permanent structure. It was built in 1936 as one of the first projects of the WPA. It is a very realistic setting for the scene where Jesus is mocked and flogged. The Roman soldiers place the crown of thorns on his head before he is led away. (Author's collection.)

Each year the chariots are checked and painted for the pageant. The props director is ever mindful of safety when animals are part of the cast. One chariot driver was tossed to the ground when the horse team ran away. Although frightening, there were no serious injuries. (Author's collection.)

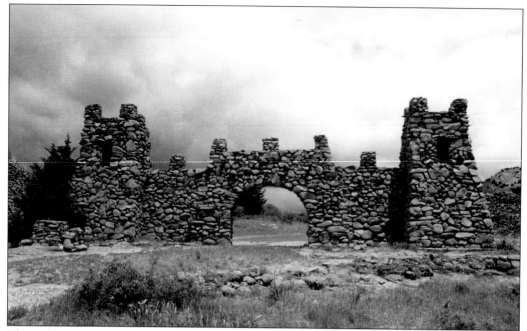

This authentic structure is the Gateway to Jerusalem. The arched opening is used in one of the pageant's most beautiful scenes, the Triumphal Entry. Jesus rides into the city on the back of the little burro as the crowd waves palm branches. It is a joyous scene as Jesus arrives at the busy marketplace. (Author's collection.)

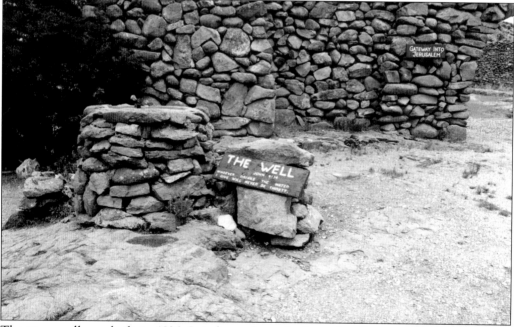

The town well was built in 1936. It is located not far from the Gateway to Jerusalem. Jesus offered a woman living water. She, in turn, brought her friends to meet him. The film *The Lawton Story* used this well. A marketplace is nearby, adding to the realism of this setting. (Author's collection.)

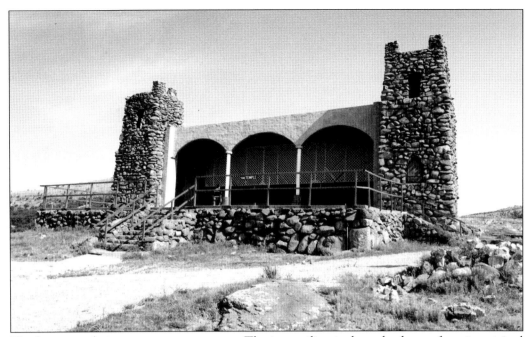

The large temple is a permanent structure. The iron railing is the only change from its original design. The plaque embedded in the native stone wall reads, "1935 Dedicated to the sacred memory of our blessed Lord Jesus whose life was offered as our example. Wichita Mountains Easter Sunrise Service founded 1927." (Author's collection.)

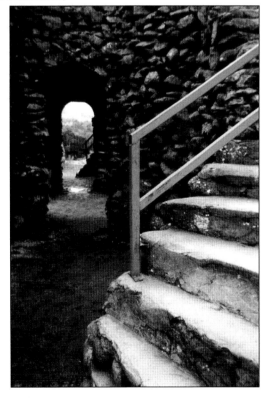

Some of the most realistic areas of the Holy City are only enjoyed by cast members or visitors on a walking tour. These stairs are used by cast members whose parts call for them to appear on the building's roof. The pathways are also used as backstage areas for actors awaiting their cues. (Author's collection.)

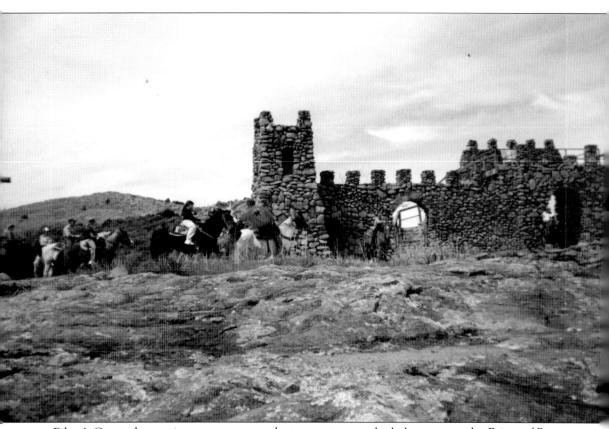

Pilate's Court plays an important part as the trumpeters on the balcony open the *Prince of Peace* pageant. Later in the pageant, Jesus appears before Pontius Pilate before being handed over to the Roman soldiers. (Author's collection.)

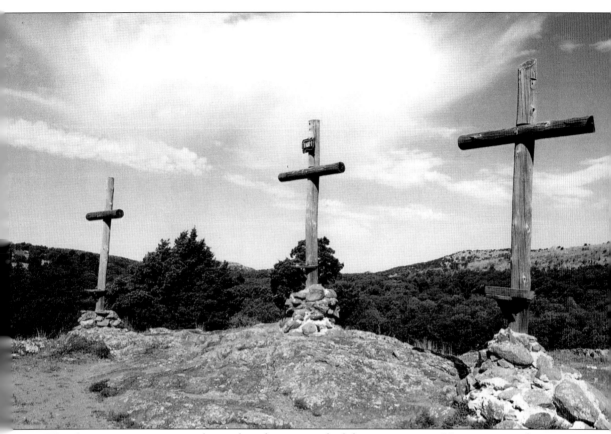

The three empty crosses are located at the west end of the staging area. Most spring nights in Oklahoma make this a very cold location for those portraying the Crucifixion. One year, Rev. Anthony Mark Wallock told those who would be on the crosses to remain in their robes because of the 32-degree weather. He later found that the three young boys had only worn loincloths. (Author's collection.)

The control center gives voices to the characters and provides music and other sound effects. Only a red light signifies that a live microphone is on during the performances. In the early days when microphones were stationed along the staging area, a herd of bleating sheep accidentally became the only sound heard. (Author's collection.)

With the number of visitors to the Holy City of the Wichitas grounds daily and the 2,000 to 5,000 who attend the *Prince of Peace* pageant, the need was great for modern restroom facilities. This was graciously supplied by the McMahon Foundation. The building is handicapped accessible and convenient to Audience Hill and the grounds of the Holy City. (Author's collection.)

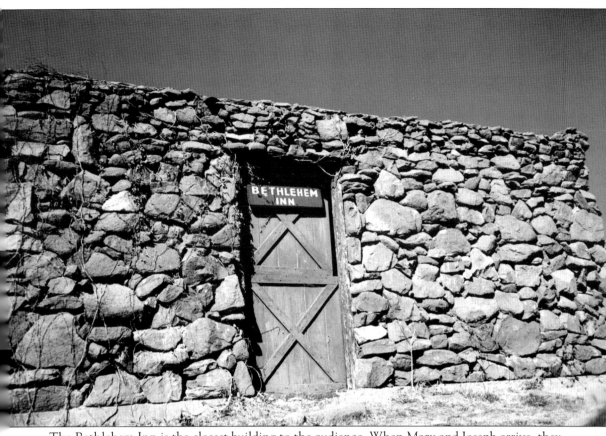

The Bethlehem Inn is the closest building to the audience. When Mary and Joseph arrive, they find no room for them, and many early travelers are sleeping on the ground. If it has rained, large sheets of plastic are spread so the actors will stay dry. After the lights go out, it is quite humorous as the once-sleeping crowd tries to stand on the slippery surface. (Author's collection.)

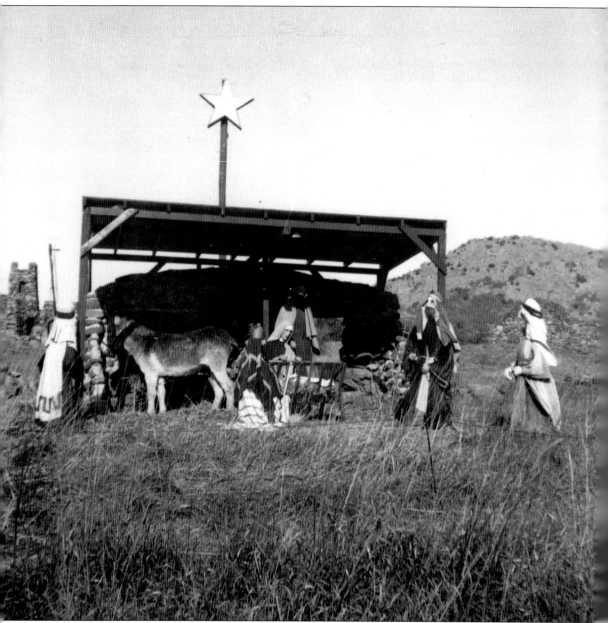

The early wooden stable is shown with the lighted star above. This is a stationary star; however, in some pageants, it was suspended from a wire that led to the stable. One year in particular, rather than the wise men following the star, it became entangled in the wire, leaving them to make the trip with the star following them. Later the stable was rebuilt of stone to match the other structures on the pageant grounds. (Wallock Memorial Museum.)

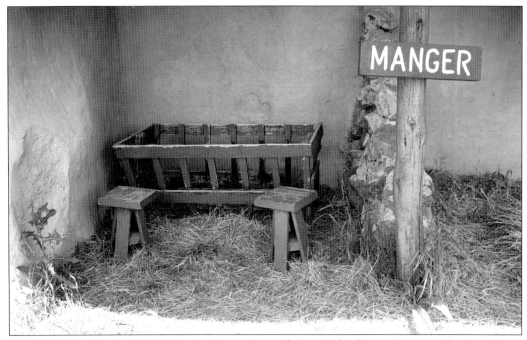

The stable containing the manger is a permanent shelter and is located next to the Bethlehem Inn. The manger is large enough to accommodate an older baby if necessary. In some pageants, the young actor refused to stay unless his mother was close by. Some infants are fascinated by the crowd with its candles and lanterns. (Author's collection.)

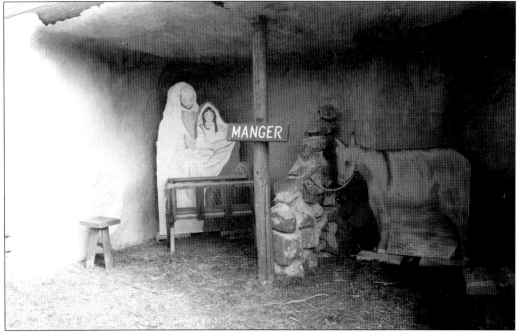

These life-size painted wood figures of Mary, Joseph, baby Jesus, and the donkey fill a vacant space in the stable when the pageant is not underway. When the cast members arrive to begin rehearsals, these substitutes are stored away in one of the buildings on the grounds. (Author's collection.)

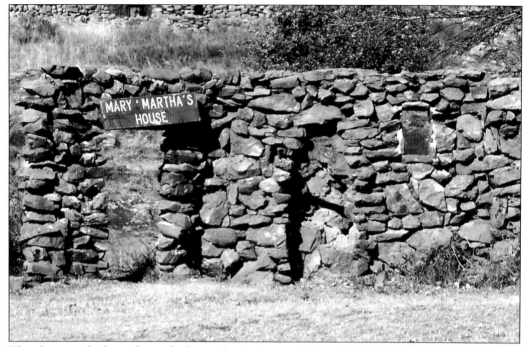

The photograph above shows the home that belongs to Mary, Martha, and their brother Lazarus. It is the site of one of Jesus's miracles. Martha sent word of her ill brother. By the time Jesus and his disciples covered the great distance, Lazarus was dead and buried. The photograph below shows Lazarus's Tomb. This very sad scene turns joyous when Jesus calls for Lazarus to come out. He appears in the doorway wearing his grave clothes. His excited sisters are told to "loose him and set him free." (Author's collection.)

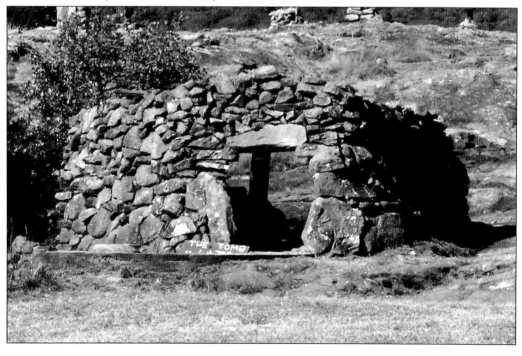

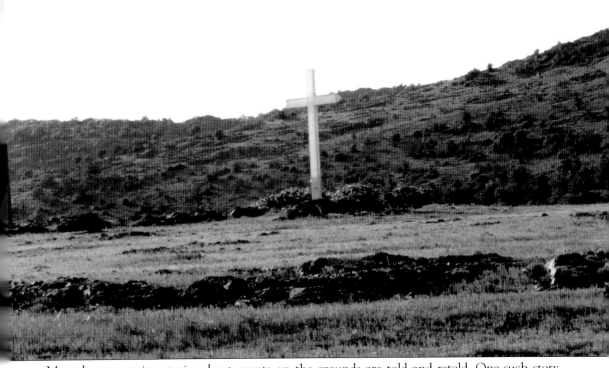

Many heartwarming stories about events on the grounds are told and retold. One such story happened during World War II. The pageant was held on the Fort Sill grounds, and German prisoners of war helped. When props were returned to the Holy City, six prisoners declined use of a truck and carried the heavy cross up Audience Hill. (Author's collection.)

As the pageant date draws close, the white cross is placed on the crest of Audience Hill. This is similar to the cross displayed in Medicine Park during the early pageant years. It is lighted and visible for several miles. During the pageant, a staffed ambulance is parked near the cross, giving peace of mind for anyone in need of medical aid. (Author's collection.)

Seven

THE PAGEANT

It has been said that a picture is worth 1,000 words. If true, the *Prince of Peace* pageant must be worth a million. The late reverend Anthony Mark Wallock, founder of the pageant, knew a visual lesson had a lasting effect. From the one-scene portrayal of the empty tomb in 1926, the pageant has evolved into a colorful living story of the life, death, and Resurrection of Jesus. The pageant starts with the all-important script. At the discretion of the pageant director, scenes may be added or deleted from the basic story. Props turn bare walls into a busy marketplace. As cast members settle into their assigned roles, the supporting cast arrives the animals. The menagerie necessary for the pageant is staggering. As many as 40 horses, a definite scene-stealing group, draped in their red and gold blankets are needed as well as camels for the manger scene, goats, pigeons that play the part of doves, and the essential donkey. With the costume-clad cast members, the biblical setting is ready. Counting back from the Easter date, rehearsals are set, and considering the changeable Oklahoma weather, an extra rehearsal may be added. Rehearsals are usually on a bright Sunday afternoon, making the date marked "night rehearsal" so critical. The rugged terrain, easy to access in the light, becomes very different in the dark. Boulders and gullies, so easy to sidestep in the daytime, could spell disaster for those unfamiliar with the night landscape. From the opening scene through the closing "Hallelujah Chorus," every age, race, and religious preference is represented in the cast. Since 1936, the date the Holy City of the Wichitas setting became the pageant's new home, the number of those attending or taking part has declined. The audience peaked in the late 1930s and 1940s when war clouds hung heavy over the nation. Those attending were searching for a source of reassurance of their faith at the Holy City. The faithful still seek this setting as each Easter, the old story ever new, is portrayed.

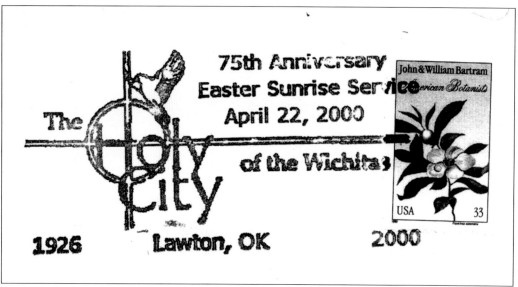

On the 75th anniversary of the Easter service, the United States Postal Service at Lawton honored it with a commemorative cancellation on April 22, 2000, featuring the Holy City logo. (Wallock Memorial Museum.)

In recent years, the Holy City of the Wichitas has had posters printed about the upcoming pageant for business windows, churches, and advertising. Although the scheduled dates always fall on Palm Sunday eve and Easter eve, the time must be adjusted from year to year depending on when the change to daylight saving time occurs. (Author's collection.)

A resolution entered into the Oklahoma State Senate by Bill Logan on March 30, 1955, reads, "That we commemorate the Wichita Mountains Easter Sunrise Service and pay our complimentary and reverent respect to the hundreds of directors, actors, costume workers, artists, traffic control specialists, and every person who toils so devotedly to help produce the great service of worship through pageantry performed each Easter." (Wallock Memorial Museum.)

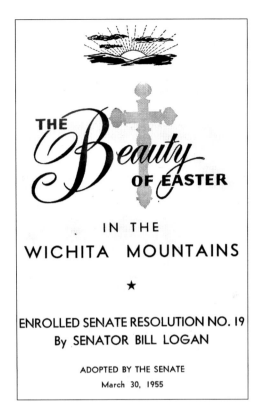

Each year, a program booklet is prepared. A brief history, a list of scenes, and the scene locations are included. Advertisements in the program are sold by the local Kiwanis club as a means of helping its organization and making the *Prince of Peace* pageant programs possible. (Author's collection.)

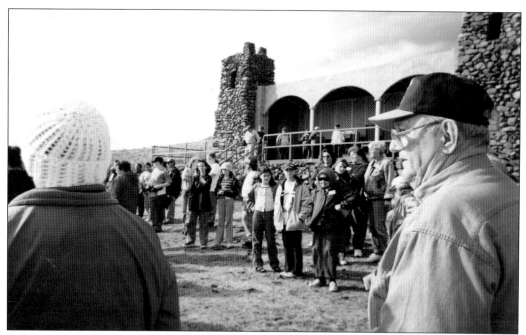

Rehearsal attendance and participation is the first indication of the success of the *Prince of Peace* pageant. The atmosphere is much like a family reunion. As the pageant draws cast members from many miles away, the long-awaited day for registration is an exciting and a much-anticipated date. Thick scripts are handed out and cast buttons are pinned on. (Jonna Lowry collection.)

When cast members arrive on the evening of the *Prince of Peace* pageant, their first stop is the registration table. It is important for the cast director and for those in wardrobe to know that the cast members will be in their assigned locations. There are no stars in the pageant, rather a group working as one to present the best pageant ever. (Author's collection.)

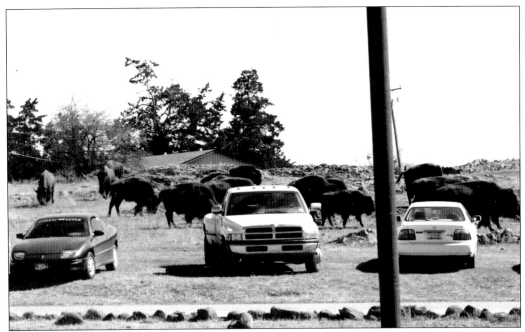

Very few years have escaped the attention of the large buffalo herd that lives on the Wichita Mountains Wildlife Refuge. The Holy City shares the same land. Although they are wild animals, they cannot resist coming to investigate what the large crowd of humans is doing. After a few rehearsals, they seem to know they do not have a part. (Author's collection.)

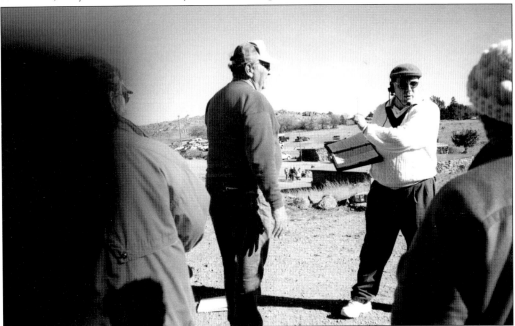

The initial rehearsal starts with work on scenes from the first half of the script. The following week, the second half is completed. Each of the remaining rehearsals is a complete 39-scene practice. As the date of Easter draws near, scripts are banned and the cast must rely on memory only. (Author's collection.)

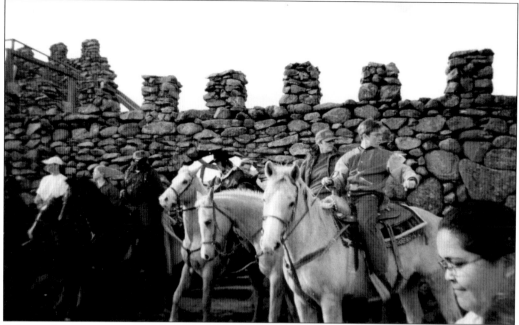

Rehearsals are necessary for the many animals that are needed for a realistic setting. Human cast members as well as animals have roles to be learned. On pageant evenings, it is necessary to know where the animals will be and for the animal cast to be comfortable with the many humans in close proximity. (Author's collection.)

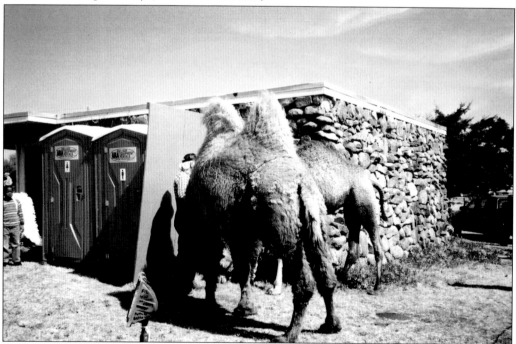

During rehearsals and on pageant nights, these necessary conveniences for the cast and crew are placed in areas hidden from the audience. It appears that the two camels, Curly and Clyde, seem to believe they are next. (Jonna Lowry collection.)

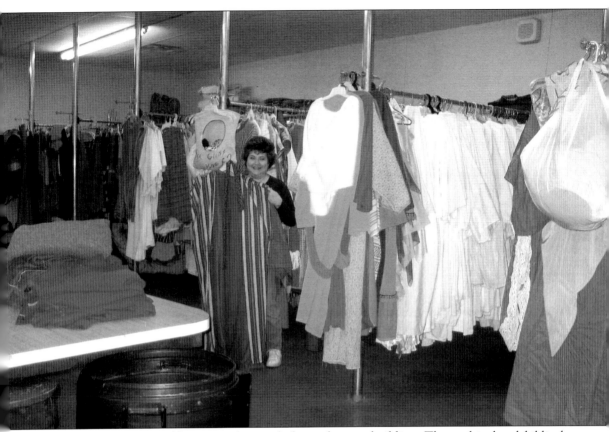

One of the newest additions is the wardrobe and props building. The multicolored biblical costumes are kept in this climate-controlled building. On the rehearsal schedule, one date is marked "costume fitting." Those in charge can quickly pull just the right clothing, wig, or beard that each character will need. (Author's collection.)

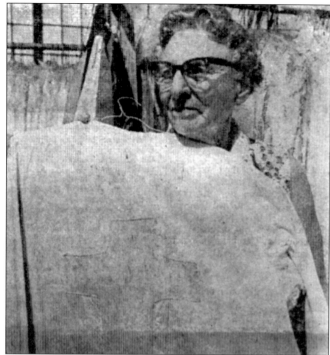

This faded newspaper article published on April 3, 1977, in the *Sunday Constitution* is all that remains of this part of the Holy City's early history. The late Frieda Sage, resident hostess for many years, is shown holding one of the Ku Klux Klan robes. She witnessed numerous historical events that occurred on the grounds. None of the robes remain. (Sunday Constitution.)

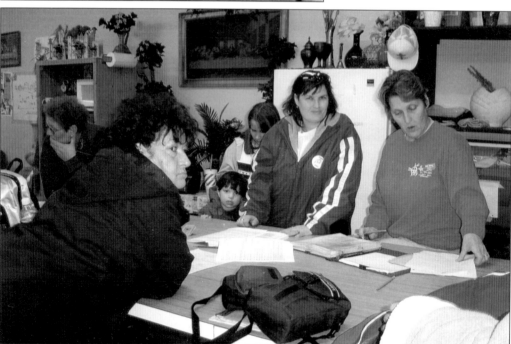

The wardrobe and props building is a busy location from the first rehearsal until the costumes are mended, washed, and stored for the next pageant. Costumes, wigs, and props are all supplied. The one exception is footwear. Rather than a delicate sandal, ankle-high hiking boots are necessary for sure footing on the jagged terrain. The colorful costumes cover warm long underwear or heavy sweatshirts needed for the usually cold spring nights. (Author's collection.)

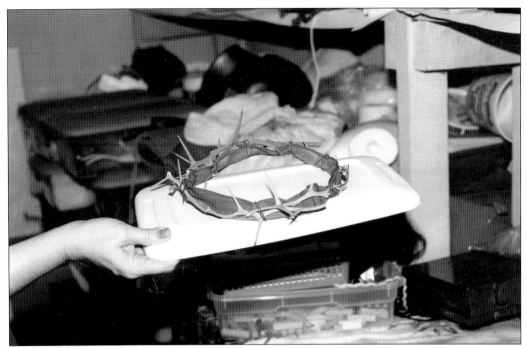

This crown of thorns is worn by the Jesus character in the Crucifixion scene. The thorns attached to this headband came from the thornbush on the Holy City grounds. The three-to-four-inch thorns can puncture a car tire. (Author's collection.)

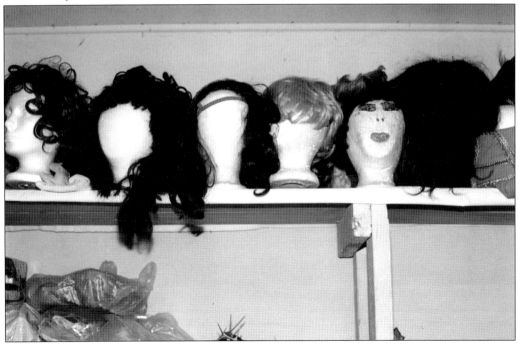

The wardrobe room has not only the correct biblical robes but hair for both men and women. With today's short hair, the longer lengths are needed. Most men grow their own beards, making the glue and facial hair for them less in demand. (Author's collection.)

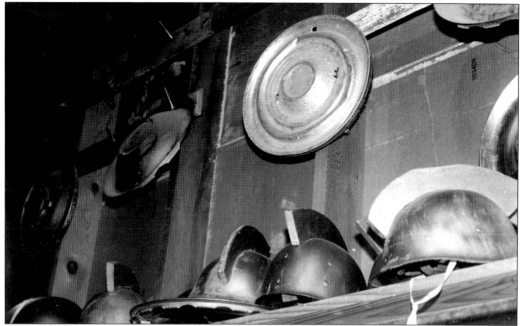

The Roman soldiers in their bright red and gold uniforms look less menacing up close. The great distance from the audience disguises the use of hubcaps for soldiers' shields. Their headgear, made from World War II helmet liners and appropriately decorated, appears very realistic. (Author's collection.)

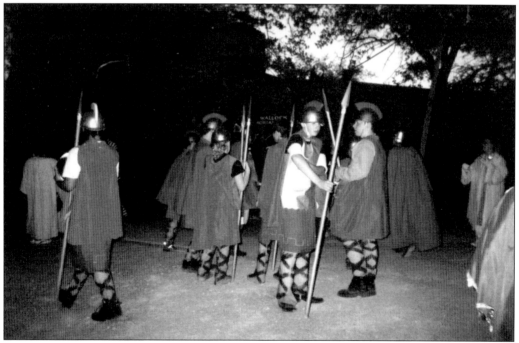

A group of Roman soldiers has left the wardrobe room and has assembled for the cast meeting always held before the opening of the pageant. The director gives last-minute instructions and says a prayer for a safe and successful pageant. (Author's collection.)

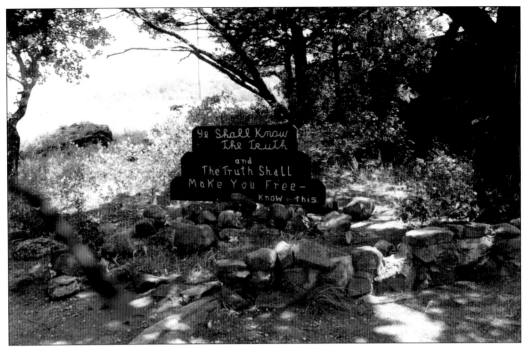

Several areas of the grounds offer a quiet spot for those walking the pathways or for those who choose to sit and rest. In the photograph above, the following message is carved into the wood marker located just outside the Moses House: "Ye shall know the truth and the truth shall set you free." In the picture below, a cast member spends some quiet time before assuming her role in one of several pageant scenes. (Author's collection.)

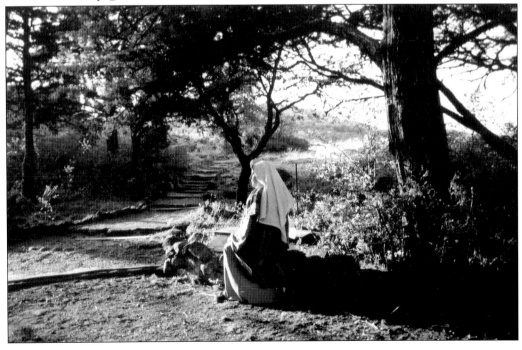

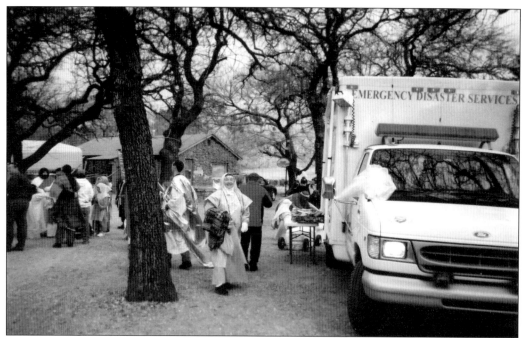

A tradition always enjoyed and much appreciated by the cast and crew of the *Prince of Peace* pageant on the grounds of the Holy City of the Wichitas is the meal served by the Salvation Army of Lawton just before the Easter performances. The Salvation Army's modern disaster relief vehicle containing a small mobile kitchen is parked under the trees in the cast area. The crisp spring evening air and excitement makes the hot dogs, sandwiches, chips, and cold drinks most welcome. The costume-clad Bible characters and Roman soldiers connected to the world by cell phones make for a humorous sight. (Wallock Memorial Museum.)

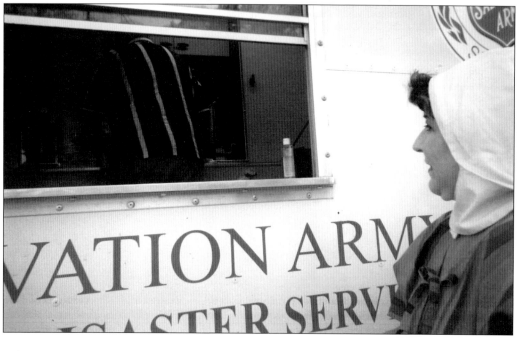

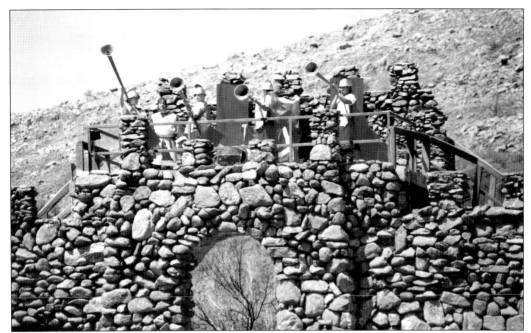

If Oklahoma's weather is agreeable, the opening scene of the *Prince of Peace* pageant is breathtakingly beautiful. From the totally dark staging area, lights flash on. In Pilate's upper court, the trumpeters' fanfare opens the pageant. Mounted soldiers in gleaming red and gold costumes set the stage as the narration begins. (Judith Feild collection.)

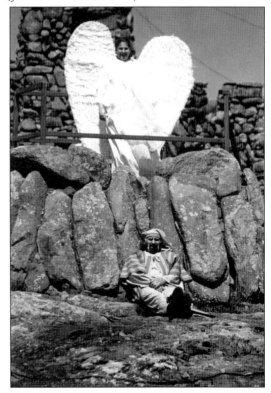

As the song "The Holy City" rings out, an angel stands on Temptation Mountain while the disciple John lies sleeping. In his dream, the Holy City behind him comes to life. Mounted soldiers and chariots enter the scene while several miniscenes are enacted as the words to the song unfold. (Judith Feild collection.)

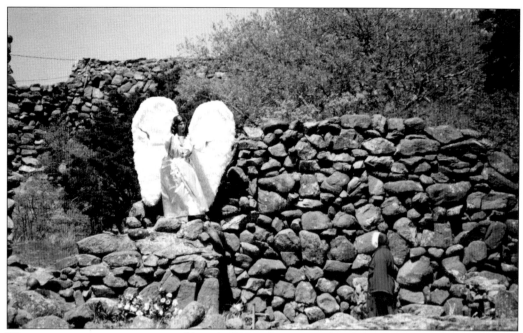

The narration continues as several hundred years have passed and the prophecies are about to be fulfilled. The angel Gabriel appears to Mary in her garden and tells her she is highly favored and the Lord is with her. From the control center comes the voice of Gabriel, which marks the start for 25 to 30 readers who will give life to the pantomimed scenes. (Wallock Memorial Museum.)

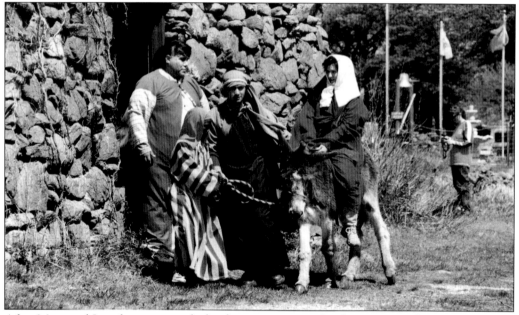

After Mary and Joseph are married, the decree to register for the census makes it necessary to travel the long distance to Bethlehem. With Mary riding a small burro and Joseph leading, the scene starts at Mary's Garden. As they travel, scene lights follow their journey to the Bethlehem Inn. Joseph pleads with the innkeeper for a room because Mary is about to give birth. They are taken to the stable. (Wallock Memorial Museum.)

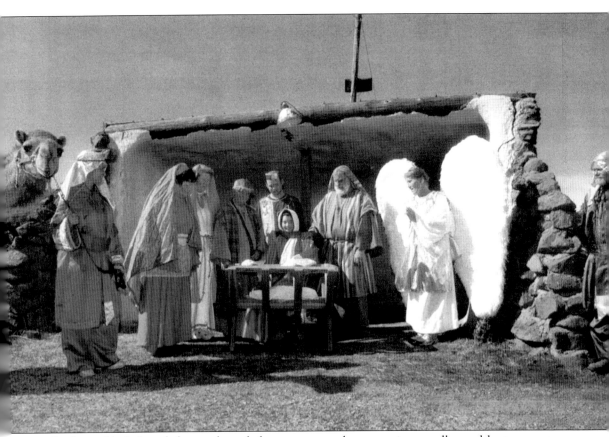

In the stable is found the newborn babe as cast members carrying candles and lanterns come from every part of the staging area to walk by the softly lighted manger. Angels, shepherds, and wise men all appear. A live baby always portrays the infant Jesus. Sometimes this youngest cast member does not appreciate all the adoration and a loud wail can be heard on Audience Hill. (Lawton Constitution.)

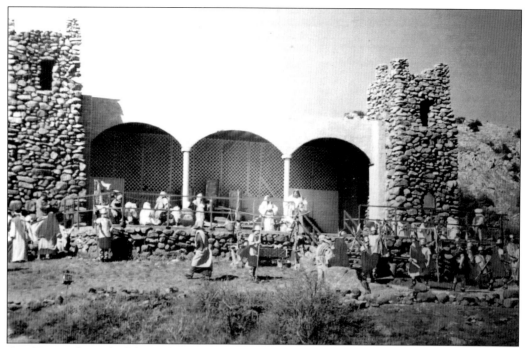

One Easter, this colorful temple setting was enveloped in a dense fog. As the lights illuminated the scene, it was reflected on the heavy clouds above, producing a truly heavenly sight. (Judith Feild collection.)

John the Baptist baptizes Jesus as a young adult. From the control center is heard, for the first time, the voice of God saying, "You are my beloved Son. In you I am well pleased." The role of Jesus is portrayed by more than one cast member, each dressed alike, making it possible to move scenes quickly across a great distance. (Wallock Memorial Museum.)

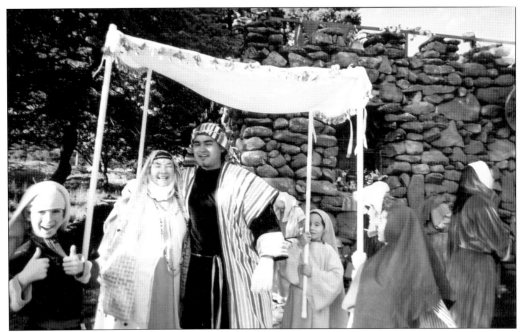

During the Wedding at Cana, Jesus performs his first miracle when he turns the water into wine. Mary, Jesus's mother, is there, along with his disciples who believe he truly is the Messiah. This is a happy scene as the music suggests a festivity. The young cast members enjoy holding the canopy over the bride and groom. (Jonna Lowry collection.)

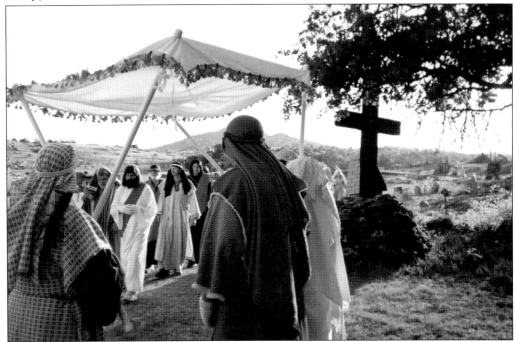

Jesus and his disciples approach the Wedding at Cana. His mother, Mary, calls the servants together and tells them to do as her son asks. It is here that Jesus performs his first public miracle when he turns the water into wine. (Jonna Lowry collection.)

As Jesus calls his 12 disciples, the characters are positioned outside the light. The Jesus character is located on a rocky mound in the lower field. As their names are spoken, they step into the light and join Jesus. To some characters, he gives new names, and to all of them, he gives new jobs. Jesus tells the new disciples the conditions for following him. (Judith Feild collection.)

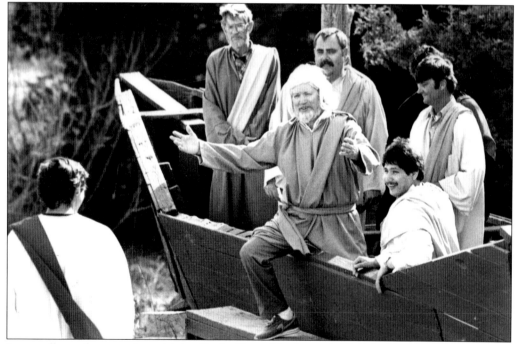

Jesus walks on the water from this landlocked boat. The fact is skillfully hidden from the audience's view by using blue-green tarps and a rocking device under the boat. The night view of the pageant makes lighting and sound an easy way to fool the eye. (Wallock Memorial Museum.)

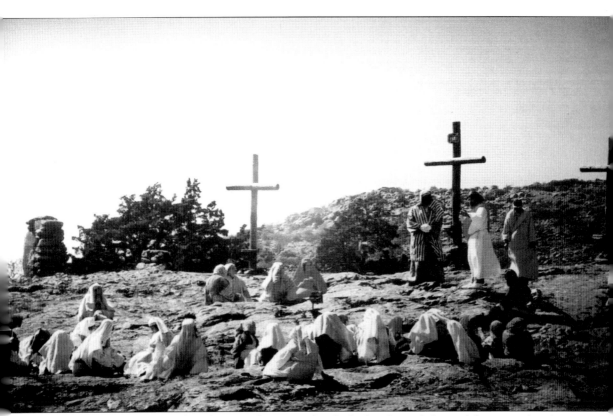
Although the ground in this photograph appears level, the height and slope of this rugged rock is very deceiving. With the three crosses visible in the background, Jesus delivers his Sermon on the Mount. After this night scene, when the lights are turned off, the cast members must carefully come to ground level in total darkness. (Jonna Lowry collection.)

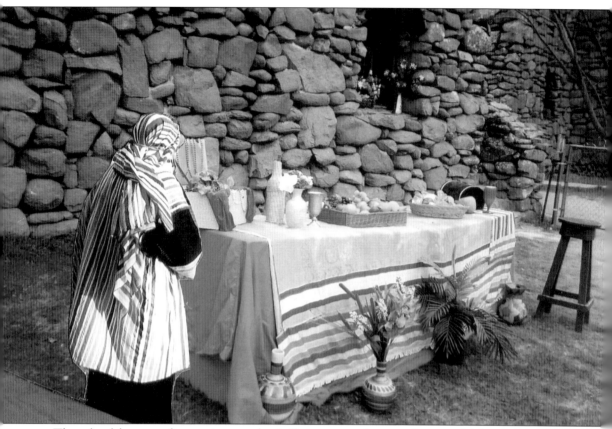

The role of the props director is not only vitally important but very fast paced. Many areas of the grounds are used for multiple scenes, making it necessary for props to be set and reset, all in total darkness. This scene, prepared for the Pharisee's Dinner, is the site of earlier scenes and will be used again as the pageant progresses. (Jonna Lowry collection.)

Of all the animals, the little burro seems to be the most popular. The pageant usually has a burro from a different family each year. Most are raised with the owner's children and are very gentle. A few have decided the event is much too long and from their holding location bray loudly and usually at the most inappropriate times. (Author's collection.)

The gentle donkeys have, at times, supplied a funny story. Years ago, several burros called the Holy City grounds home year-round. They were free to explore grounds and buildings, if left open. The frugal costume director used a group of mismatched crepe paper wings in a variety of colors year after year. While exploring, the donkeys had them for lunch. (Author's collection.)

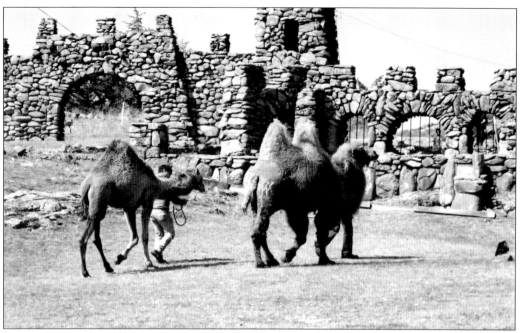

The Holy City is very fortunate to have two special camels as members of the pageant. Their handlers dress for the scene and become part of the cast. Clyde and Curly have a very heavy appointment schedule, and the pageant is quite honored to have them make a most impressive appearance. (Jonna Lowry collection.)

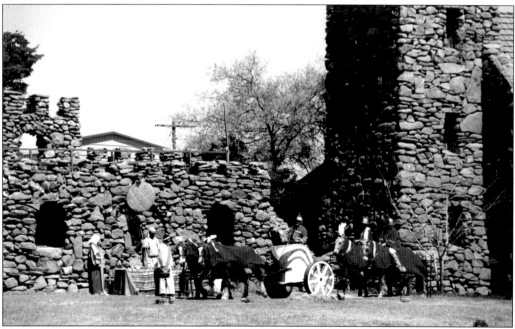

The chariot-pulling horse team in its finery is always a scene stealer. In some pageants, the pair of horses is a matched team. One year, extra horses were needed, and the horses that pulled the garbage wagons in Lawton donned the fancy drapes of red and gold and for one evening became royalty. (Judith Feild collection.)

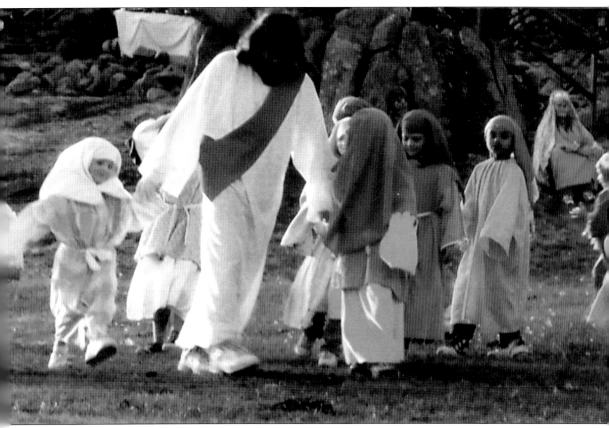
Jesus plays with the children. From the control center, the recorded voices of young children talking and singing are used during this charming scene. Some seasoned cast members got their start in this scene. (Jonna Lowry collection.)

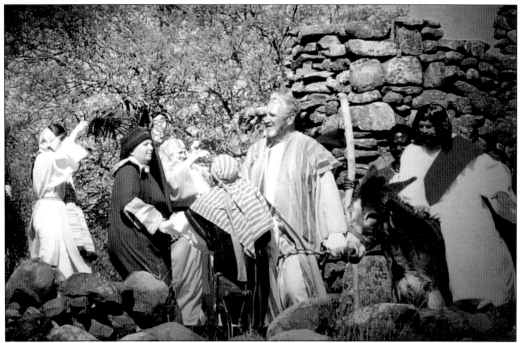

Peter leads the donkey as Jesus rides into the city of Jerusalem. People in the marketplace wave their palm branches. Donkeys of every personality have had a part in the pageant. Occasionally one balks at his new role and leaves Jesus to walk. (Judith Feild collection.)

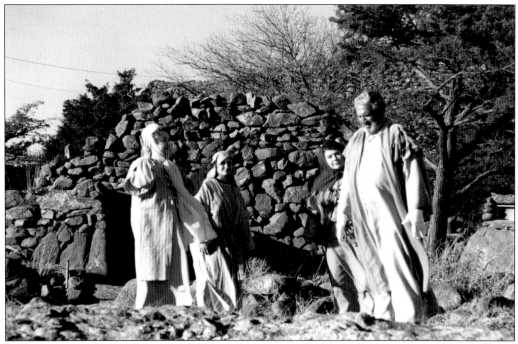

Three women walking by recognize Peter as one of the disciples. He had fled the garden when the Roman soldiers appeared. The women confront him. As Peter fears for his life, he denies knowing Jesus as the cock crows in the distance. (Judith Feild collection.)

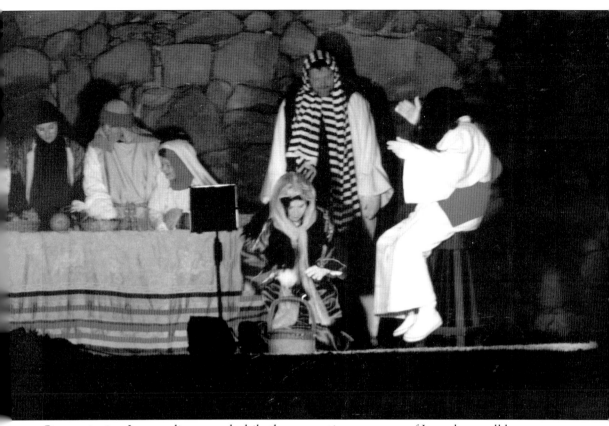

Simeon invites Jesus to dinner, and while they are eating, a woman of Jerusalem, well known as a sinner, enters the room. She washes his feet with her tears and dries them with her long hair. All cast members wear white gloves to enable the audience to see their hands more easily as they pantomime their parts. (Jon Paul Lowry collection.)

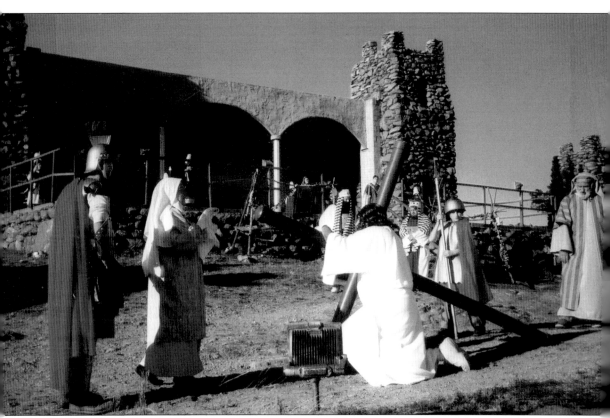
In the March to Calvary, Veronica runs to Jesus as he falls under the weight of the cross. She pleads, "Jesus, let me help you." The centurion orders her to move away. (Jonna Lowry collection.)

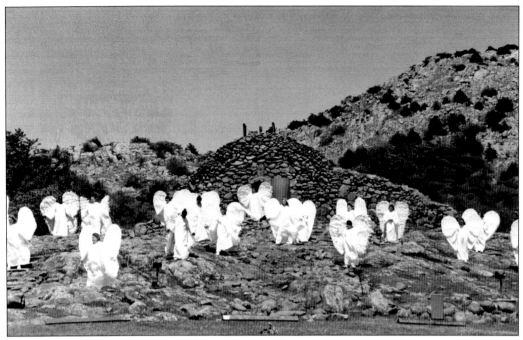

The *Prince of Peace* pageant has always had angels. Angels appear in the opening scene and throughout the program. The closing scene, the "Hallelujah Chorus" is a setting with more than 300 angels spotlighted over the entire half-mile staging area. Under extremely windy conditions, angels must appear wingless or risk an unplanned flight. In the daytime dress rehearsal photograph above, it is all-important for the angels to note their locations as the ground appears very different in total darkness. The final scene (below) is breathtakingly beautiful as angels of all sizes cover the grounds and the music fills the hillside. (Wallock Memorial Museum.)

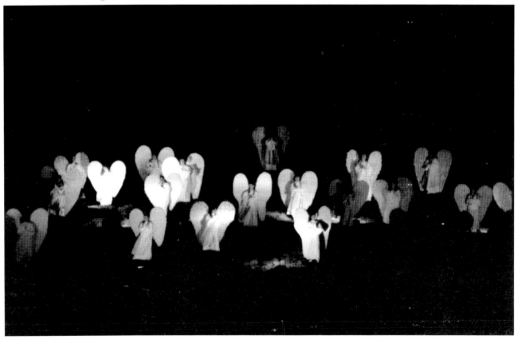

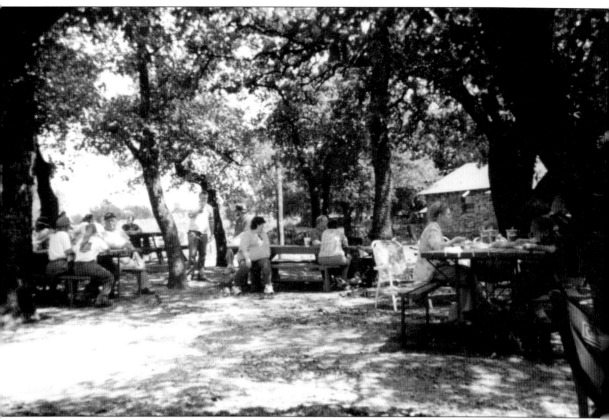

Each year after the pageant, the cast and technical crew has a Sunday afternoon picnic under the trees outside the gift shop. As most men from the cast have shaved their beards and cut their hair, some introductions are often necessary. The picnic serves as a family gathering, as for most cast members it will be nearly a year before they will meet again. (Author's collection.)

"Worship"

by-Ruth Furbee

God made my cathedral
Under the stars;
He gave my cathedral
Trees for spires;
He hewed me an altar
In the depth of a hill;
He gave me a hymnal
A rock-bedded rill;
He voiced me a sermon
Of heavenly light
In the beauty around me—
The calmness of night;
And I felt as I knelt
On the velvet-like sod
I had supped of the Spirit
In the Temple of God.

Included above is a poem by Ruth Furbee that was first printed in *Masterpieces of Religious Verse*, edited by James Dalton and published by Harper and Brothers in 1948. (*Masterpieces of Religious Verse*.)

Across America, People are Discovering Something Wonderful. *Their Heritage.*

Arcadia Publishing is the leading local history publisher in the United States. With more than 3,000 titles in print and hundreds of new titles released every year, Arcadia has extensive specialized experience chronicling the history of communities and celebrating America's hidden stories, bringing to life the people, places, and events from the past. To discover the history of other communities across the nation, please visit:

www.arcadiapublishing.com

Customized search tools allow you to find regional history books about the town where you grew up, the cities where your friends and family live, the town where your parents met, or even that retirement spot you've been dreaming about.